100 YEARS *of* Art *in* SAN DIEGO

SELECTIONS FROM THE COLLECTION OF

THE SAN DIEGO HISTORICAL SOCIETY

A Catalogue of the works of Artists Active in San Diego
from the 1850's to the 1950's

by
Bruce Kamerling

**SAN DIEGO
HISTORICAL
SOCIETY**

ISBN 0-918740-12-6
©1991 by San Diego Historical Society
P.O. Box 81825
San Diego, California
92138

The author dedicates this catalogue to Betty Quayle for her untiring assistance with the documentation and preservation of San Diego's artistic record.

DESIGN
Jill K. Maxwell-Berry, Artista Artworks

PRINTING
Conklin Litho

PAPER
The paper used in this publication meets the minimum requirements of American National Standards for Information Sciences-Permanence of Paper for Printed Library Material, ANSI Z39.48-1984.

PHOTOGRAPHY
Artwork photographed by Nick Juran

Photograph of Leonardo Barbieri courtesy the California Historical Society, photograph of Harry Cassie Best courtesy Virginia Adams, photograph of Frank Heath courtesy Margaret Koch, photograph of Elliot Torrey courtesy San Diego Museum of Art, photographs of Reginald Machell and Edith White courtesy The Theosophical Society, Pasadena. Additional photography by John Redfern.

All other photographs are from the San Diego Historical Society Photograph Collection (many of which have been added to the collection by the artists, their friends and relatives).

FRONT COVER:
 Charles Reiffel mural (catalogue number 34)
BACK COVER:
 Arthur Putnam *Indian* (catalogue number 15)

Table of Contents

We would like to thank the following individuals and companies
for their support of
100 YEARS *of* ART *in* SAN DIEGO
Without their generosity, this catalogue would not have been possible.
We would also like to extend our special thanks to Barbara Walbridge
who was a guiding light in the creation and successful execution of this project.

Major Donors
Florence Christman
The Fieldstone Company
Barbara Walbridge

Benefactors
Beth Paynter Fund, San Diego Community Foundation
Jean Swiggett Memorial Fund

Patrons
John Foster
Gwendolyn W. Stephens
Barbara J. Witherow
Captain & Mrs. Bennett Wright

Sponsors
Harry W. Evans
Mr. & Mrs. Philip M. Klauber
Rear Admiral J. L. Howard

Additional Donors
Mrs. Nelson E. (May) Barker
Mrs. Anderson Borthwick
Phyllis E. Brown
Mr. & Mrs. E. Scofield Bonnet
Mr. & Mrs. Alex DeBakcsy
DeRu's Fine Arts
Ms. Pauline des Granges
Willis & Jane Fletcher Foundation
Mr. & Mrs. Daniel Jacobs
Mr. & Mrs. LeRoy W. Knutson
David Lewinson Gallery
Mrs. Mavina McFeron
Mr. & Mrs. James S. Milch
Mrs. Jack L Oatman
J. R. Ridgway, Sr.
Reverend & Mrs. C. Boone Sadler
Dr. & Mrs. Paul M. Saltman
Mr. & Mrs. Jean Stern
Donald J. Williams, M.D.
David Zapf Gallery

Preface

This catalogue is the first scholarly survey of the artists of San Diego represented in the collection of the San Diego Historical Society. It is part of a series that will ultimately provide catalogues on several leading San Diego artists. The first of the series, *Sunlight & Shadow: The Art of Alfred R. Mitchell, 1888-1972*, was published by the Society in 1988.

Since its inception in 1928, SDHS has been collecting the works of San Diego artists. For the past 13 years, the Society's Curator of Collections, Bruce Kamerling, has accorded a high priority to collecting, preserving and interpreting San Diego's rich artistic heritage.

The Society places special emphasis on local works of art, not only because they illustrate and document the changing visual environment of the San Diego region, but because they reflect the changing cultural and artistic development of the community. Works of art are important historic documents of the time in which they are created. They reveal the changing values and attitudes of each generation and often reveal their aspirations and visions as well. Even works of art that depict historic events tell us more about the times in which the artist created the work than about the historic times being portrayed. Through the years, the San Diego Historical Society has benefited from the generosity of those who have recognized the value of art in documenting and interpreting the region's history. Almost all of the 900 pieces in our art collections have been donated.

Thanks to the foresight of these donors and the perseverance of Bruce Kamerling, today the Society's art collection is recognized as one of the most comprehensive collections of local art in the Southwest. In the years ahead the Society will continue to develop this outstanding collection and to make it available to the public through exhibition and publication.

James M. Vaughan
Executive Director

Introduction

San Diego was once considered to be an important art center in the west. During the period covered by this catalogue, over 500 local citizens were active in some branch of the fine arts, many as their primary occupation. A significant number of these professional artists had reputations far beyond San Diego County. Many had trained in the major art schools in America and Europe and worked, studied, exhibited and won awards all over the world.

A little over a decade ago, in an attempt to preserve and interpret this rich artistic legacy, the San Diego Historical Society began to actively collect the work of San Diego's early artists. Before that time, the Society's art collection consisted primarily of paintings of an historical nature or portraits of prominent citizens. The recent emphasis has been to acquire representative works of art by a broad range of artists who worked or lived in San Diego. Now numbering about 900 pieces, this collection includes paintings, sculpture, prints and drawings as well as artists' working models, sketches, tools and equipment, archival collections, photographs and oral histories. Together these materials provide an outstanding resource for the study of San Diego's artistic heritage.

Although the collection is already surprisingly rich, there are several areas where growth is anticipated. Some major artists are still represented only by minor works. Other notable artists such as Ruth Ball, Charles Cristadoro, Eugene and Pauline DeVol, Sarah Truax and Benjamin Vaganov, among others, are not yet represented. In recent years, an attempt has been made to bring the collection more up to date by collecting works of the post-war era. These will be the challenges of the future.

This catalogue presents the work of fifty artists who were active in San Diego from the 1850s through the 1950s. Some of the names will be familiar, but the majority are little known today. It is remarkable that many of the artists well-known in San Diego's past have long since slipped into obscurity. Our purpose here is to reintroduce some of these early artists and attempt to place them in the context of local history.

A project of this type would not have been possible without the encouragement and support of many people. First, I would like to thank the many artists and their families and friends who have been so very generous in their gifts of artwork and other material. Their belief in the mission of the Historical Society has been most gratifying. Second, I would like to thank the donors who have realized the importance of this project and been willing to provide the funds necessary for its successful completion. Next, I would like to thank the outstanding staff of the Balboa Art Conservation Center who have treated many of the pieces in this collection. Finally, I would like to thank the staff members and volunteers of the San Diego Historical Society who have assisted in a variety of ways. Without the support of all these people, this first-ever overview of the history of art in San Diego could never have been accomplished.

Bruce Kamerling
Curator of Collections

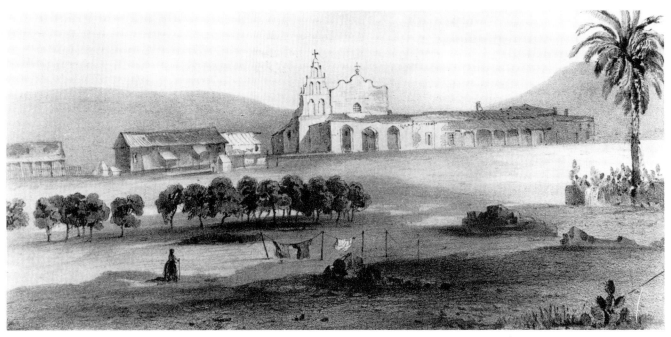

Color lithograph of the San Diego Mission published in the railroad survey of 1853 after a drawing by Heinrich Mollhausen.

The Early Years

The first artists in San Diego were the native inhabitants who created petroglyphs, pictographs and clay slab dolls which can still be found at several sites around the county. With the arrival of the Spanish colonists in 1769, sacred images in the form of religious paintings and statues were imported from Mexico to adorn the chapel of the Royal Presidio, missions San Diego de Alcala and San Luis Rey, and the assistencias at Santa Ysabel and Pala. Mission San Luis Rey still preserves many of these original works of art.

Some of the early expeditions to California, several of which stopped in San Diego, included artists of varying skill who recorded their observations in drawings and watercolor paintings. Although usually of more historical than artistic interest, these images provide a rare and valuable glimpse at San Diego's appearance in the years before the arrival of the camera. In 1827-28, Auguste Bernard Duhaut-Cilly visited California and later published an engraving of Mission San Luis Rey, based on one of his drawings, in *Voyage Autour du monde* (1834). This is the earliest known work of art done in San Diego County.

Following the Mexican-American War of 1846 and statehood in 1850, various military, boundary and railroad expeditions passed through San Diego. Artists who accompanied these expeditions published the first lithographic views of San Diego. These include a view of Old Town after a drawing by John Mix Stanley in William H. Emory's *Notes of a Military Reconnaissance from Fort Leavenworth in Missouri to San Diego in California* (1848) and a view of the San Diego mission after a drawing by Heinrich Mollhausen in Lt. R. S. Williamson's *Report of Explorations in California for Railroad Routes* (1853).

The first professional artist to create independant works of art in San Diego appears to have been Leonardo Barbieri, an itinerant Italian portrait painter, trained in Europe, who had come to California from South America. In 1850, Barbieri painted a charming portrait of Rosario Estudillo Aguirre (catalogue number 1) which is the first documented work of fine art known to have been produced in San Diego. Barbieri may also have painted portraits of Rosario's cousin, Maria de Jesus Estudillo (Bancroft Library, Berkeley) and Lt. Thomas W. Sweeny (San Diego Historical Society) on the same visit.

After California achieved statehood, San Diego opened up to other American artists. In 1852, Henry Cheever Pratt came to San Diego as part of the Boundary Commission. Pratt, a Boston artist who had studied painting under Samuel F. B. Morse, exhibited some of his work in San Diego in April of 1852. This is the earliest recorded art exhibition held in California. George Catlin, famous painter of Indian portraits passed through San Diego in 1855 on his return

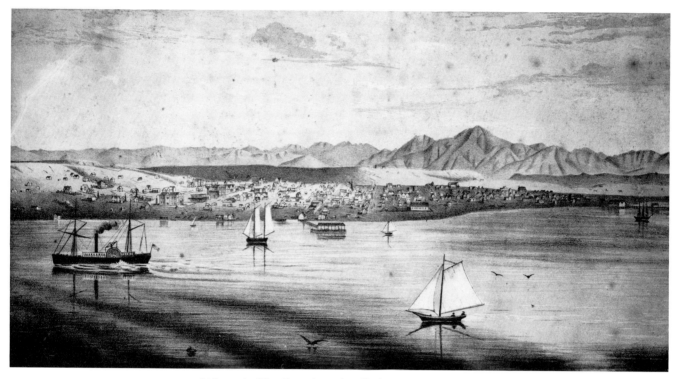

Lithograph of San Diego drawn by Alfred E. Mathews in 1873.

from studying Indians in South America and Mexico.

During it's first three decades as an American town, San Diego led a rather sleepy existance. A few artists visited long enough to record their impressions of the area in sketches or published lithographic views. Photographs exist of a drawing of San Diego Bay signed "Jas. Whittle" and dated 1869, but the original has disappeared. Alfred E. Mathews visited San Diego during the winter of 1872-73 and later published lithographs of San Diego, San Bernardino, Los Angeles and Santa Barbara. George H. Baker produced a lithograph of San Diego about 1873 and Eli S. Glover executed a "Bird's Eye View" of San Diego in 1876.

San Diego did not begin to develop a community of resident artists until the 1880s. Miss Emma M. Chapin, who settled here in 1881, appears to have been the first professional resident artist. She produced portraits and taught art and remained active in local art circles until her death in 1911. Other professional artists visited San Diego in the 1880s including Henry Chapman Ford, Frank Heath and Bruce Porter. William T. Black and Ammi M. Farnham were among those who decided to stay.

Although there were no commercial art galleries in San Diego at this time, other opportunities were available for artists to show their work. Large shop windows along Fifth Street between E and G streets including Rockfellow's shoe store, Daggett's drug store and the photo gallery of Parker and Son displayed the work of local artists. Art was also shown at bookstores such as those of A. Schneider and J. C. Packard, both of which carried art supplies as well. San Diego's first commercial art galleries were the Art Palace at 928 Sixth Street and Louis Dampf at 962 Third, both of which date to the economic boom of 1887-88. At the height of San Diego's boom, the City Directory listed eight artists, six dealers in artists' materials and three art teachers. A dozen artists were listed in 1889-90, but William T. Black alone was listed in 1892 and no artists at all between 1893 and 1901. The boom had gone bust and taken most of San Diego's art community with it.

Several artists did choose to remain in San Diego during this period. Ammi Farnham maintained his faith in San Diego and stayed here between trips to Europe and Buffalo, New York. Charles Fries arrived in the mid 1890s to become one of San Diegos best-known artists. Arthur Putnam worked here in the 1890s, and in 1896 offered to create a sculpture of Juan Cabrillo for the city. Two of San Diego's first native artists, Alice Klauber and Annie Pierce, were also becoming active at this time. By the end of the century, San Diego had a small but dedicated group of artists who helped pave the way for the future growth of the city's artistic community.

Leonardo Barbieri

born: Duchy of Savoy, ca. 1810
died: Duchy of Savoy, ca. 1872/73

After art studies in Lyon, France, Barbieri abruptly abandoned Europe for South America. In the mid 1840s he worked in Argentina and later in Bolivia. He seems to have been attracted to California by news of the gold strike and by December of 1849, had established himself in San Francisco. While in California, Barbieri painted over thirty portraits of prominent Californios and Americans who married into Californio families. He worked in San Diego, Santa Barbara, Monterey and the San Francisco Bay area. By July of 1853, Barbieri had traveled to Mexico where he may have participated in Count Gaston de Raousset-Boulbon's ill fated attempt to take Sonora in 1854. Barbieri had relocated to Peru by 1856 where he started an art academy in Lima. In 1860, he organized the first art exhibition ever held in Lima. Returning to Europe about 1871, Barbieri spent his final days in his native village in Savoy.

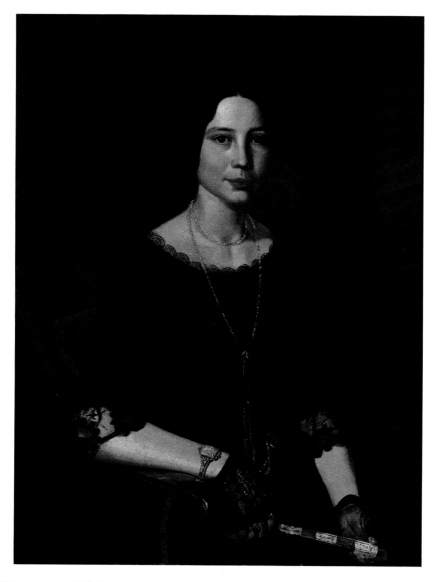

1. Rosario Estudillo Aguirre (1850)
oil on canvas, 32" x 24"
signed and dated lower right
On extended loan from the Pico family (1988-L-4)

Barbieri's portrait of Rosario Aguirre (1828-1895) is the first documentable work of fine art produced in San Diego. Dona Rosario's husband, Jose Antonio Aguirre, one of the wealthiest men in California, may have seen Barbieri's work in San Francisco and arranged for the painter to portray his wife. Barbieri also painted Rosario's cousin, Maria de Jesus Estudillo, the wife of Don Antonio's partner, William Heath Davis. One of Barbieri's most charming works, the portrait of Dona Rosario is full of rich detail including the embroidered mitts, cameo bracelet, gold chain and other jewelry. Family

tradition records that Barbieri painted the portrait at the Casa de Estudillo, and received $500 for his efforts. Aguirre was in San Francisco in 1849 and returned to San Diego with Davis in 1850, when they and four associates attempted to start a "New Town" closer to San Diego bay. The portrait must have been painted at that time.

Works in collection:
1 oil (extended loan), 1 oil (attributed)

William Thurston Black

born: New Jersey, ca. 1816/17
died: San Diego, California, August 7, 1893

Black may have studied at the National Academy of Design, New York, where he exhibited in 1845, 1850 and 1851. He may also have studied at the Pennsylvania Academy of Fine Arts as he had a Philadelphia address in 1850 and exhibited at the Academy that same year. Black moved to Detroit by 1866, where he pursued a thriving business portraying prominent citizens until about 1884. Heading west, Black settled briefly in Los Angeles before continuing south to San Diego. Although he had not intended to stay in San Diego, Black remained here for the rest of his life. By July of 1885, he had established a studio in the Backesto Block and announced his ability to paint portraits from life or from "photographs of deceased persons." He continued to work in San Diego and the 1892-93 City Directory listed his name in bold print, perhaps indicating a successful portrait business.

2. Alonzo E. Horton (ca. 1885)
oil on canvas, 29 1/4" x 24"
inscribed on reverse with artist's name
Gift of the San Diego
Chamber of Commerce (1949.3)

Often called the "Father of New San Diego," Alonzo Erastus Horton (1813-1909) founded the town of Hortonville in Wisconsin before heading west in 1851. Arriving in San Diego in 1867, he thought that the town then growing around the old Spanish/Mexican village was poorly situated for future growth. Purchasing the land that now comprises most of downtown San Diego, he developed "New Town" and was influential in the city's growth for over forty years.

This is undoubtedly the portrait of Horton which Black exhibited at the County Fair in 1885. News accounts of the period record it as being "beyond criticism, both as regards to likeness to the original and artistic workmanship." A copy of the painting, which belonged to Horton's brother-in-law, William Bowers, and hung in the Florence Hotel, is also in the Historical Society's collection. A third portrait of Horton showing the sitter from the waist up seated at a table with his arm resting on a map of Horton's Addition, may also be by Black. Now in the Historical Society's collection as well, this third portrait is inscribed "Black" on the frame, which appears to be original. The directors of the San Diego Chamber of Commerce purchased Black's original portrait from the artist's widow in 1899. At the present time, it is the only positively identified painting from Black's years in San Diego.

Works in collection:
1 oil, 1 oil (copy, possibly by Black),
1 oil (attributed)

7

BLACK

Ammi Merchant Farnham

born: Silver Creek, Chautauqua Co., New York, January 13, 1845
died: San Diego, California, July 20, 1922

Farnham may have started his art studies at the Buffalo Fine Arts Academy. In the 1870s, he studied at the Royal Academy of Bavaria in Munich. Among his classmates were William Merritt Chase, Frederick Freer, and Walter Shirlaw. He also studied under Frank Duveneck who later opened his own school in Munich. About 1877, Farnham returned to America after additional studies in Italy and France. Settling in Buffalo, he became an instructor at the Buffalo Female Academy and was also associated with the Buffalo Fine Arts Academy where he became an officer in 1880 and served twice as curator. Sometime around 1888 or 1889, Farnham moved to San Diego. Although now considering San Diego his home, he often traveled to Europe and maintained his ties with art circles in Buffalo. He exhibited in cities all over the country, and won a silver medal at the 1915 Panama-California Exposition in San Diego. During the exposition, the San Diego Art Guild was formed and hailed Farnham as its first "dean." His memorial exhibition at Orr's Gallery was the largest one-man show held in San Diego up to that time and included oils, watercolors and etchings.

3. Pastoral Landscape (ca. 1900)
oil on canvas, 19 1/2" x 36"
signed lower right
Gift of Lawrence Laughlin (1981.64.1)

Even after settling in San Diego, Farnham continued to travel and paint along the east coast and in Europe. He completed a number of works in England, his wife's homeland. One source records that "When painting in the European countries, it always was Mr. Farnham's custom to make his home with the most humble rural families to get an intimate contact with nature." This work is similar to other paintings done near Salisbury, England, and certainly depicts the same locale. It is a typical example of what one early critic referred to as "...his characteristic tender coloring — delicate atmosphere, grey suffused with color." The donor's father, Dr. Nimrod D. Laughlin, received this painting from the artist in exchange for medical services (see also catalogue number 8).

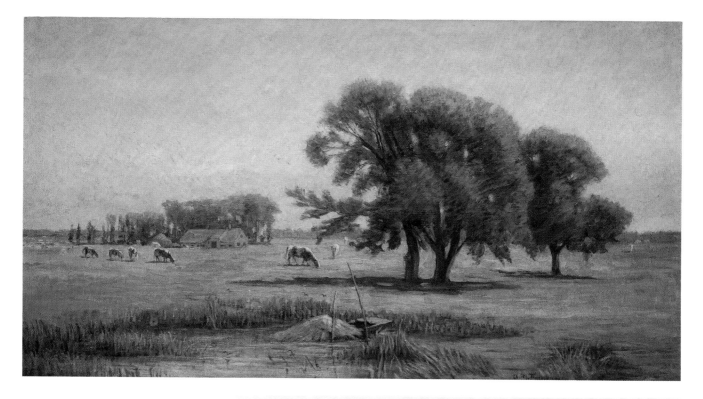

4. Mission San Diego de Alcala
(ca. 1890)
etching, 5 1/2" x 8 3/4"
signed lower right
Society Purchase (1990.53)

Junipero Serra founded the San Diego mission on July 16, 1769, the first of the twenty-one Spanish missions established in Alta California. Originally founded on Presidio Hill, the mission was moved to its present site at the eastern end of Mission Valley in 1774. Rebuilt several times, the final structure was dedicated in 1813. After the Mexican revolution of 1821, San Diego became a Mexican outpost and in 1833 the government ordered that all church property be secularized. The mission began to deteriorate and by the 1870s had been reduced to a picturesque ruin, a favorite subject for photographers and artists (see also catalogue numbers 6 and 18). Dated photographs of a nearly identical view of the mission verify that Farnham's etching must have been done soon after his arrival in San Diego. He is known to have etched several other missions including Santa Barbara and San Gabriel.

Works in collection:
3 oils, 1 etching

9

Frank L. Heath

born: near Salem, Oregon, July 3, 1857
died: Santa Cruz, California, April 21, 1921

Heath's parents moved to Santa Cruz in 1866. His father opened a mercantile store and was twice elected to the California State Legislature. In 1874, Heath began his art studies at the Mark Hopkins Art Institute in San Francisco and he also studied under Raymond Yelland of that city. From 1875 to 1885, Heath maintained a studio in San Francisco. Returning to Santa Cruz in 1885, he helped found the Society of Decorative Art. In the late 1880s and early 1890s, Heath traveled around the country painting and sketching until returning to Santa Cruz in 1895. His enormous *Bird's Eye View of Santa Cruz* was exhibited at the Chicago World's Fair in 1893 and he also exhibited at the St. Louis World's Fair in 1904. Heath and his students became known as the Jolly Daubers and were the forerunners of the Santa Cruz Art League which he helped found in 1919. He served as first president of the organization.

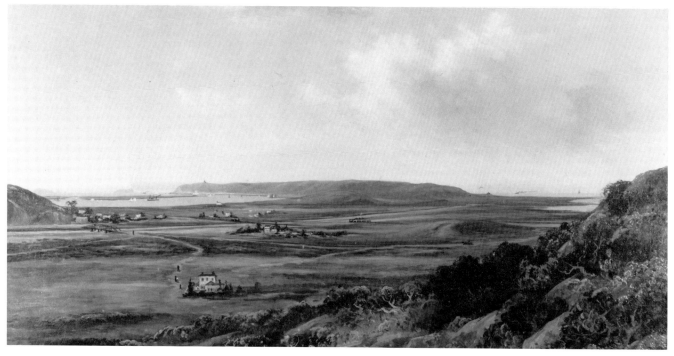

5. View from Shirley and DeWitt's Addition (1888)
oil on canvas, 24" x 44"
signed lower right, dated on reverse
Donor not recorded (1900.1.5)

In January of 1887, the *San Diego Union* mentioned that Heath was spending the winter in San Diego making sketches. That same month he had a private showing of many of his paintings which received favorable comments in the newspaper. The Society's painting is inscribed on the reverse with the title and date 1888. This might indicate that Heath stayed for a year in the San Diego area or returned for a second trip the following year.

Heath's *View from Shirley and DeWitt's Addition* depicts the western end of Mission Valley looking from the slope below the present site of the University of San Diego toward Old Town and Point Loma. Frank B. Shirley and John D. DeWitt, bookkeepers at the First National Bank, were among the many land speculators during San Diego's brief real estate boom of the late 1880s. Heath depicts the sweeping panorama of the scene and is careful to record several local landmarks. On the far left, below Presidio Hill, the famous "Serra Palm" can be seen next to Old Town. He has also shown the lighthouse on Point Loma and the recently completed Cliff House hotel in Ocean Beach as well as the Coronado Islands and Southern California Railraod. An early photograph of the San Diego College of Music and Art Palace at 928 Sixth Street shows this painting on an easel in the store window. Its history since that time is not known.

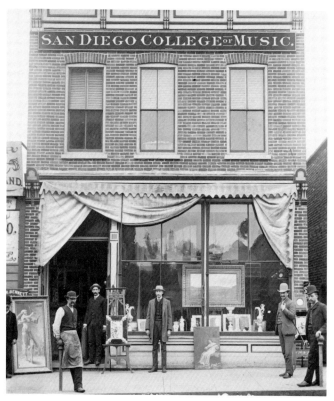

San Diego College of Music & Art Palace

Works in collection:
1 oil

Bruce Porter

born: San Francisco, California, February 23, 1865
died: San Francisco, California, November 25, 1953

Largely self-educated, Porter left school at the age of fourteen. He pursued his interest in the arts through independant studies in Paris, London and Venice, although most of his career was centered around his native San Francisco. Multi-talented, Porter was a painter, landscape designer, muralist, stained glass designer, poet and critic. A Chevalier of the Legion of Honor in France, he also maintained memberships in the Bohemian Club in San Francisco, American Painters & Sculptors, and served as secretary of the San Francisco Guild of Arts and Crafts. With Gelett Burgess he co-founded a magazine called *The Lark* in 1895, and contributed illustrations, essays and poetry to its pages. Perhaps his best known design is the monument to Robert Louis Stevenson in Portsmouth Square, San Francisco.

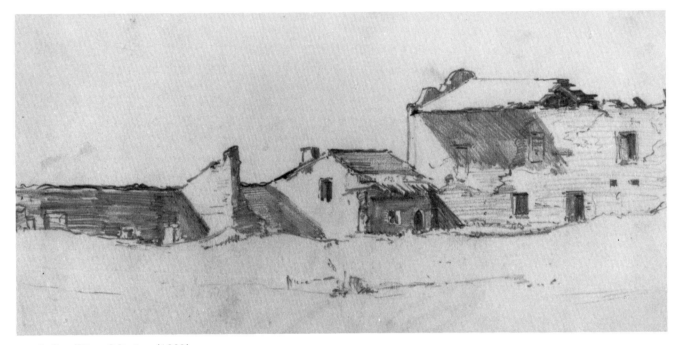

6. San Diego Mission (1889)
pencil, 5 3/4" x 8 3/4"
initialed and dated lower right
Donor not recorded (1931.5.5)

The Historical Society's collection contains a number of Porter's sketches in pencil and wash that depict the San Diego mission, Old Town, and the ruins of the Royal Presidio. Several of these are dated 1889, and one of them is dated February 23, 1889, the artist's twenty-fourth birthday. Another drawing from the same visit showing the Casa de Aguirre is in the possession of the descendants of Rosario Estudillo Aguirre (see catalogue number 1). Porter was obviously attracted to the tangible remains of San Diego's romantic Hispanic past. Unlike many artists who drew inspiration from the mission ruins (see catalog numbers 4 and 18), Porter chose to depict the remaining structures from the interior court which shows them in a much more deteriorated condition. The artist later returned to San Diego to design stained glass windows for the Christ Episcopal Church in Coronado in 1894, and the Children's Home Association in San Diego about 1905.

Works in collection:
9 drawings

Carl Christian Zeus

born: Germany, July 14, 1830
died: Berkeley, California, July 1, 1915

Little is known about the early life of Carl Zeus other than the fact that he studied at the Royal Academy of Art in Munich. He had arrived in California by 1889, when he founded an art school in the Farmer's Union Building in San Jose. Mention is also found of him in Anaheim and he may have taught at Stanford University. Zeus is known to have exhibited at the World's Columbian Exposition in Chicago in 1893.

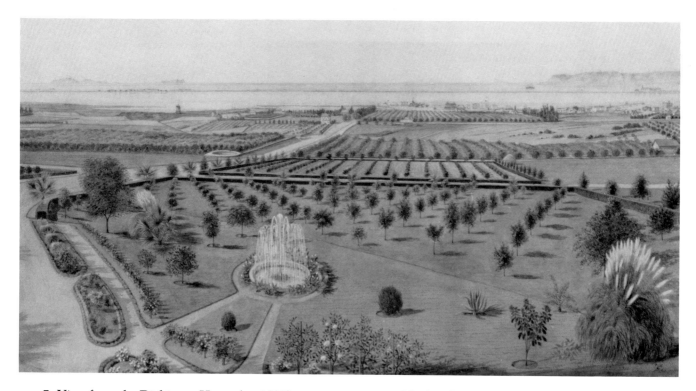

7. View from the Dickinson House (ca. 1890)
watercolor, 10" x 14 1/8"
monogrammed lower right
Gift of Ann B. Donahoe (1985.15)

The Dickinson-Boal house, still standing on East 24th Street in National City, was built in 1887 for Col. William Green Dickinson. Dickinson had been sent to manage the San Diego Land and Town Company in 1886, and purchased forty acres in National City. He hired the firm of Comstock and Trotsche, architects for the San Diego County Courthouse and Jesse Shepard's Villa Montezuma, to design the eclectic Queen Anne style residence. As manager of the Land and Town Co., Dickinson was involved with the construction of Sweetwater Dam and the National City and Otay Railroad. After his death in 1891, the house was occupied by his daughter, Mary, and her husband, John E. Boal, who took over as manager of the Land and Town Co. The donor's father was Edgar Dickinson Boal.

Zeus' painting, done from the third story of the house, shows the view toward the bay, and is painted in the meticulous style often found in 19th century watercolors. The beautiful garden with fountain and orchards has been carefully rendered, making it easy to identify roses, palms, pampas grass and agave. In the distance the Coronado Islands, Hotel del Coronado and even the Point Loma Lighthouse can be seen. A backing sheet was inscribed "Memorial Album Leaf of Leland Stanford Junior University Carl C. Zeus Anaheim, Cal."

Works in collection:
1 watercolor

Charles A. Fries

born: Hillsboro, Ohio, August 14, 1854
died: San Diego, California, December 15, 1940

At the age of fifteen, Fries became apprentice to a lithographer in Cincinnati where he remained until 1874. While continuing to work as a lithographer and photographer, he studied at night at the Cincinnati Art Academy and his work began to win awards. In 1876, Fries traveled briefly to England, but returned and established a studio in Cincinnati. He continued as a lithographer and his illustrations were published in *Harper's*, *Century*, and *Leslie's* magazines. In 1887, he and his wife moved to New York where he continued to produce illustrations and execute portrait commissions. Fries moved to California in 1896 and first established a residence in the ruins of the San Juan Capistrano mission. The following year, he moved to San Diego where he remained for the rest of his life. Fries was one of the first professional artists to establish himself in San Diego and inherited the title "Dean of San Diego Painters" after the death of Ammi Farnham in 1922. In 1929 he became one of the original members of Contemporary Artists of San Diego. Beginning in 1907, Fries kept a journal numbering and recording his paintings. At the time of his death, it contained nearly 1700 entries.

8. Still-Life with Lobster
(ca. 1905)
oil on canvas, 16" x 24"
signed lower left
Gift of Lawrence Laughlin (1981.64.6)

Although primarily known as a landscape painter, Fries completed a number of still-life paintings in the early years of this century. The Historical Society owns four such paintings, none of which has a Fries catalogue number, indicating that they were finished and sold before he began his catalogue in 1907. In this work, Fries has carefully distinguished between the textures of the table surface, metal pail, radishes, greens and hard red shell of the lobster. In some areas, the paint has been thickly and boldly applied, and in others it is extremely thin and transparent creating interesting surface variations. The donor's father received the painting in exchange for medical services (see also catalogue number 3).

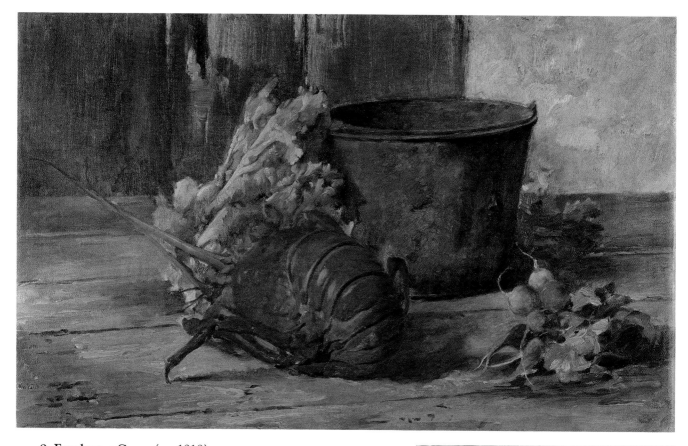

9. Eucalyptus Grove (ca. 1918)
oil on board, 18" x 12"
signed lower left
Gift of Mr. & Mrs. Morris Spillard
(1976.15.8)

This painting is listed as number 555 in the Fries catalogue with the notation that it was sold for $50 "By Willa to a Young Man." There are other references in the catalogue to "Cousin Willa" and "Willa Spillard, Hollywood," indicating that the donors were related to Fries.

Eucalyptus Grove was rapidly painted in a highly impressionistic manner unusual for Fries. Unlike the artist's typical technique of using paint sparingly, it has here been generously applied in thick brushstrokes with purple-blues and pale yellows predominating. The non-distinct, almost abstract arrangement of lights and darks is broken by the vertical clusters of tree trunks which echo the vertical format of the composition.

Works in collection:
17 oils, 1 watercolor, 5 drawings,
 2 etchings, archival material

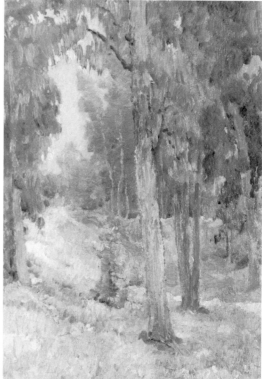

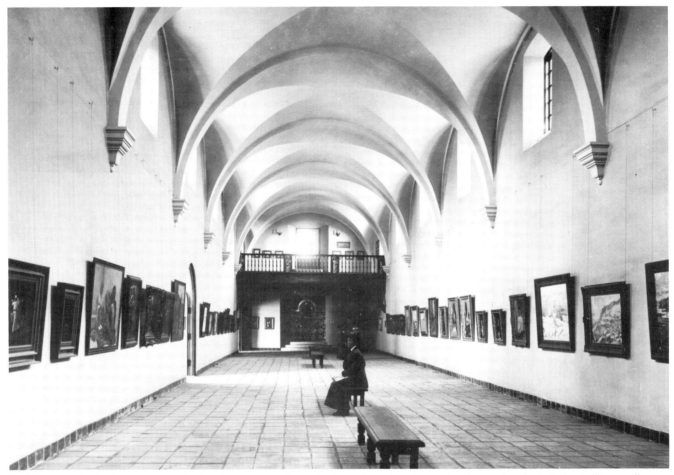

Constructed for the Panama-California Exposition in 1915, the south wing of the California Quadrangle served as the city's first public art gallery.

The Dawn of a New Century

San Diego's core of resident artists greatly increased in the early years of this century. These artists gathered together to found the San Diego Art Association which incorporated on August 19, 1904, with Daniel Cleveland as president. The group stated its purpose to be "...the study and encouragement of art in all its higher branches" and to establish art schools, develop collections of art and maintain buildings for their use. Members held their first art exhibition in July of 1905 on the second floor of the old Carnegie Library in downtown San Diego. Among the exhibiting artists were Charles Fries, Ammi Farnham, Annie Pierce and Alice Klauber. Besides exhibitions, the Art Association also sponsored lectures including a talk on Velasquez by Alice Klauber in December of 1909 and one on Joaquin Sorolla y Bastida by Henry E. Mills in April of 1910. The membership roster for 1909-10 lists over one hundred names including

architect Irving Gill, businessmen George Marston and Julius Wangenheim, Dr. Peter C. Remondino and the recently arrived artists Anna and Albert Valentien.

In 1897, Katherine Tingley established the international headquarters of the Theosophical Society on Point Loma and encourged artists to relocate there. The first artists to move to Lomaland, as it became known, were the English painters Charles J. Ryan and Reginald Machell, who arrived in late December of 1900. Other artists followed including Edith White, Gay Betts, Maurice Braun and Leonard Lester. The Point Loma Art School developed as part of the Theosophical Society's Raja Yoga Academy and taught art in the traditional academic manner. Theosophical doctrine manifested itself in various ways in these artists' work, but shows up primarily as an interest in "hidden" qualities similar to the work of Symbolist artists in Europe.

Maurice Braun, one of the artists drawn to San Diego because of the Theosophical Society founded the San Diego Art Academy in 1910 in the Isis Theater building owned by Katherine Tingley. He maintained the school until about 1919 and then convinced Eugene and Pauline DeVol to move here from Chicago and establish an art school about 1920. The San Diego Academy of Fine Arts opened in the old Sacramento Building in Balboa Park on January 10, 1921, and remained a vital part of San Diego's art scene until the Navy took over the park buildings in World War II.

When San Diegans learned that the Panama Canal was scheduled for completion in 1915, they decided to hold a world's fair in honor of the event since San Diego would be the first U.S. port of call for ships coming through the canal. San Francisco also made its bid for an exposition and eventually won out over San Diego for the officially sanctioned international exposition. Undaunted, San Diego decided to proceed with its plans for an exposition but concentrate on cultural rather than industrial exhibits. San Diego's fair, the Panama-California Exposition took place in an artificially created city of fanciful Spanish Colonial style buildings in Balboa Park. The city's population at this time was slightly over 35,000 making it the smallest city ever to host a world's fair. Due to its success, the fair was held over a second year and renamed the Panama-California International Exposition when some of the foreign exhibits were shipped to San Diego after the close of the San Francisco fair.

Alice Klauber was named chairman of the art department for the fair and Dr. Edgar Hewett director of exhibitions. Together they organized a show of work by some of America's foremost contemporary artists with the aid of Robert Henri, a friend of Klauber. Among those who exhibited were George Luks, Maurice Prendergast, William Glackens, John Sloan, Childe Hassam, George Bellows and Henri. This was the first time San Diego had been exposed to a major exhibition of contemporary American art. The official art show for the fair, juried by the California Art Club in Los Angeles, consisted primarily of California artists among whom were Carl Oscar Borg, Maurice Braun, Ammi Farnham, E. Charlton Fortune, Alfred Mitchell, Hanson Puthuff, Donna Schuster, Albert Valentien and William Wendt.

Most of the exposition buildings were of temporary construction and intended for demolition after the fair. The Navy took over the park buildings during World War I, thereby saving many from destruction. After the war, a number of local artists established studios in the structures including Ruth Ball, Alice and Leda Klauber, Henry Lovins and Annie Pierce. The exposition's Fine Arts building was in the south wing of the California Quadrangle, one of the few

Lomaland, the headquarters of the Theosophical Society on Point Loma, attracted a number of artists to San Diego.

permanent structures built for the fair. This served as the city's art museum until 1926.

By the time of the exposition, the San Diego Art Association had become defunct. In September of 1915, several interested artists gathered in the Hotel Barstow to establish the San Diego Art Guild. For the next decade they operated in rooms of the B Street School and various sites in Balboa Park. In 1920, a group of lay members called the Friends of Art formed with the purpose of bringing traveling exhibits to San Diego and trying to obtain a gallery for shows and permanent collections. Also in 1920, a group of artists banded together to form the La Jolla Art Association with Mrs. Eleanor B. Parks as president. Among the original members were Maurice Braun, Charles Fries, Alice Klauber, Nora Landers, Alfred Mitchell, and Anna and Albert Valentien.

In 1925, Mr. and Mrs. Appleton S. Bridges offered to build an art gallery for the city if a group would organize to operate it. The Friends of Art reorganized as the Fine Arts Society and elected a governing board of thirty members. The board hired Reginald Poland for the position of director in which capacity he served for nearly twenty-five years. From the beginning, it was decided that the term "gallery" rather than "museum" would be used. In addition to developing a permanent collection, the gallery would show and offer for sale work by local and other contemporary artists. Poland felt that the purpose of the gallery was to encourage art in the community and he did much to shape the future artistic growth of San Diego. The gallery changed its name to the San Diego Museum of Art in 1979.

Reginald Willoughby Machell, R.B.A.

born: Crakenthorpe, Westmorland, England, June 20, 1854
died: San Diego, California, October 8, 1927

Educated in Uppingham and Owen's College, Machell received many prizes in drawing and also in the classics. In 1875, he traveled to London to further his art studies, and the following year went on to study at the Academy Julian in Paris. Returning to London in 1880, he devoted himself to portrait painting and began exhibiting at the Royal Academy. Machel was introduced to Helena Blavatsky, who had founded the Theosophical Society in 1888, and did some interior decoration for the meeting hall at her headquarters in 1890. Under Blavatsky's influence Machell's work became more mystical and symbolic. The Royal Society of British Artists elected him to membership in 1893 and he began exhibiting with them. After receiving an invitation to join the Theosophical headquarters staff at Point Loma, he relocated there in December of 1900. He became actively involved with the decoration of the principal Lomaland buildings, the Academy and Temple, including architectural ornamentation, decorative mural designs and elaborately carved furniture, doors and folding screens. In addition to these activities, he became an accomplished actor as well as a writer and illustrator for Lomaland publications.

10. The Prodigal (ca. 1895)
oil on two separate canvases; top 32 3/4" x 28 3/4",
bottom 13" x 28 3/4",
in handcarved frame by the artist 56" x 39"
Unsigned.
Gift of Mr. & Mrs. Iverson Harris (1974.9)

The Prodigal, also titled *The Kingdom of Heaven is Within You*, is typical of Machell's complicated allegorical subjects. Machell wrote a pamphlet on "Symbolical Art" in which he stated: "I believe every form in nature, including human nature, is an outward and visible symbol of inward and spiritual forces. Thus all nature is symbolical, and ourselves and our lives are symbolical representatives of the eternal drama of the Soul." He believed that the human form offered the best means of expressing "...the complex forces that move beneath the surface of life," and that "Art should lead human progress and throw light upon its path, ever suggesting the unseen in the seen."

In the New Testament book of *St. Luke*, Jesus recounts the parable of the prodigal son who asks his father for his share of the family estate, and then loses the money through reckless living. Reduced to feeding swine, he repents his folly and says "I will arise and go to my father" (15:18), who quickly forgives him and welcomes him home. Machell's pamphlet on "Symbolical Art" includes the following description of *The Prodigal*:

The Prodigal human Soul, leaving the mansion of his Father in Heaven, has wandered to the far land of earth. There he has squandered his spiritual patrimony in riotous living, and is reduced at last to "feed the swine." The swine in the parable are they who, with their heads bent earthward, feed their mind on soulless knowledge of material things.

The Prodigal, condemned to feed others with such food, "is fain to fill his belly with the husks that the swine did eat," that is to fill his mind with the dead-letter knowledge of the book-worm.

At last he turns, saying, "I will arise and go to my Father," that Father which is in Heaven; and, rising above his dark surroundings, freed from the senses that have held him down, he bathes in the undying Light. "The knowledge of It is a divine silence and the rest of all the senses."

The upper panel shows the Prodigal Soul surrounded by the ethereal colors and heart-shaped halo of a divine light. Around him are the heavily draped "swine" with heads lowered. In the bottom panel, the "book-worm" sits in his dark library with hands clasped, staring out blankly at the viewer. The quotation carved in the center of the frame is from *The Divine Pymander* (verse 17, Book Four, "The Key") of Hermes Trismegistus, an honorific designation given to the Egyptian Hermes (Thoth), god of wisdom. A number of mystical and gnostic writings were gathered together in ancient times and called the *Corpus Hermeticum*, of which the Pymander forms the first collection. Theosophical doctrine does not include an anthropomorphic god. Followers recognize instead that all beings including humankind are expressions, each in its own way, of Universal Divinity. It is this Universal Divinity that is referred to in the quotation carved in the frame.

Machell's work shows an indebtedness to the English Pre-Raphaelite painters and the European Symbolist movement. The Pre-Raphaelites helped rediscover the Italian artists of the 15th century, and in the process began to use Italian Renaissance devices such as the predella (narrow bottom panel), to augment the story in the main panel. Dante Gabriel Rossetti used a predella in his *Beata Beatrix* and *The Blessed Damozel*, and several followers of the Pre-Raphaelites including Edward Burne-Jones and John Strudwick also used the device. It is interesting to note that in *The Prodigal* the paint does not extend beyond the openings of the frame, indicating that the frame, with its flowing Art Nouveau lines and organic forms, was made first.

The Prodigal was painted in England some time before Machell departed for Point Loma. He brought this and several other paintings with him and most of these were displayed in the Academy building at Lomaland. When the Theosophical Society sold the Point Loma property and

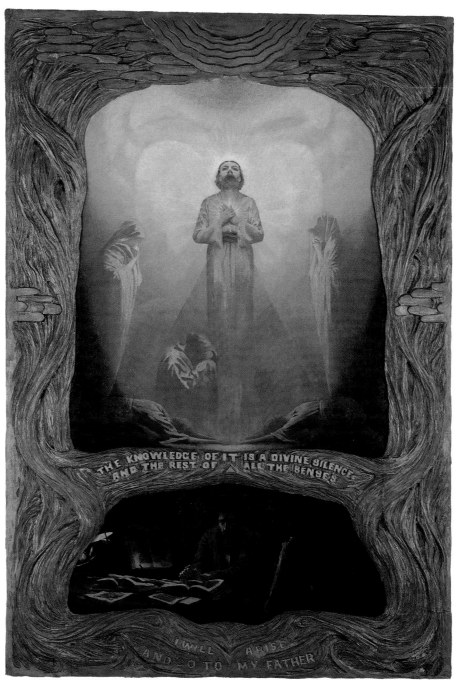

moved to Covina in 1942, many of the furnishings and art works were sold privately and at auction. This painting was retained by the artist's son, Montague Machell. Montague's widow left it to the donor, Iverson Harris, who had been Katherine Tingley's traveling secretary.

Works in collection:
4 oils (two in one frame), 4 carved chairs

Edith White

born: near Decorah, Iowa, March 20, 1855
died: Berkeley, California, January 19, 1946

As a child, Edith White came across the plains with her family to a mining camp in Nevada County, California. She became a graduate of Mills College in Oakland and later studied at the San Francisco School of Design. In 1882 she opened a studio in Los Angeles, moving ten years later to New York for further study at the Art Students' League. She returned to California in 1893 and opened a studio in the Green Hotel in Pasadena. Becoming a member of the Pasadena Lodge of the Theosophical Society in 1897, she made the move to Point Loma in 1902 where she became the principal instructor of art at the Raja Yoga Academy. She left Point Loma in the Depression year of 1930, returning to the Bay Area where she worked in Oakland and Berkeley.

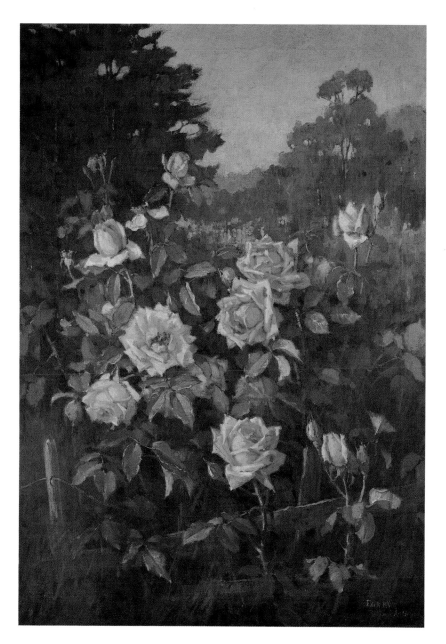

11. Roses on a Fence (ca. 1915)
oil on canvas, 32 1/4" x 23"
signed lower right
Gift of Mrs. Iverson Harris in memory of her husband
(1979.17.12)

Although White did paint landscapes, she is best known for her flower pieces and roses were her specialty. This painting is unusual in that she has chosen to depict the large pink tea roses outdoors rather than in a vase or other arrangement. The scene is certainly one of the gardens at Lomaland and the tall eucalyptus trees in the background provide the distinctive California touch. White has inscribed "Point Loma Art School" under her signature, indicating her connection to the Raja Yoga Academy.

Works in collection:
5 oils

Leonard Lester

born: Cumberland Lake District, England, February 4, 1870
died: Grossmont, San Diego County, California, June 26, 1952

Educated in the Quaker tradition in England, Lester showed an interest in art in his early teens. He accompanied his family to Canada in 1889, and later into the United States. Moving to Los Angeles, he found a job making drawings for *The Art Amateur*. In 1892, he received the commission to produce large pen and ink illustrations of several buildings for Chicago's Columbian Exposition. While there he met William Quan Judge, American leader of the Theosophical Society, and he became a Theosophist. During the mid 1890s, he studied at the National Academy of Design, the Art Student's League and the Pennsylvania Academy of Fine Arts. About 1896 he returned to California where at various times he had studios in Los Angeles, Pasadena, Santa Barbara, Redlands and Montecito. From 1900 to 1902 he traveled and painted in Germany, England, France and Italy. After visiting Lomaland in 1907, he left for Cuba where his sister was in charge of the four Raja Yoga Schools which Katherine Tingley had started after the Spanish-American War. He taught art there until the schools closed in 1910, but remained in Cuba until moving to Point Loma in 1916. In 1929, Lester left Lomaland and established a studio in Alpine where he painted for ten years. His final studio was in Grossmont where he worked until a year or so before his death.

12. Elfin Forest - Moonrise (ca. 1935)
watercolor and gouache, 16" x 20"
signed lower left
Gift of Marian Lester (1982.52.4)

The stock market crash of 1929 had a serious impact on the resources of the Theosophical Society. At that time, many of the Lomaland residents who could support themselves were requested to leave to help ease the bad financial situation. Lester moved to the Julian Eltinge Ranch near Alpine where his health, which had suffered in the damp Point Loma air, was restored. During the next decade, he produced numerous drawings and paintings of the San Diego backcountry.

Lester exhibited a group of his paintings and crayon drawings at Studio 6 in the House of Hospitality, Balboa Park, in April of 1937. Reviewing that exhibition in the *San Diego Sun*, Marg Loring wrote "The 'Elfin Forest,' which is the botanists name for arid land covered with small shrubs, abounds around Alpine where Mr. Lester lives. He has treated his painting by that name with such delicacy and refinement of feeling that the sight of it conjures up the very scent of the wild lilac and sage and a fresh mountain air seems to emanate from it." *Elfin Forest* is thinly painted primarily in cool blues, greens and lavenders without any strong lines or contrasts. Lester had a special interest in moonlight effects. An opaque white has been used to emphasize the moon and some of the clouds and this adds to the otherworldly atmosphere.

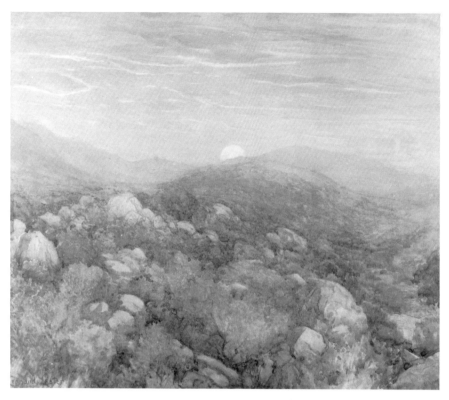

13. Moonrise, Alpine (ca. 1935)
crayon on toned paper,
12 1/2" x 16 1/2"
signed lower left
Gift of Jim Stelluti (1982.27.5)

Lester began experimenting with crayons on toned paper while he was still at Point Loma. He found the medium well suited to his ethereal style. In *Moonrise -Alpine*, he worked from dark to light letting the deep tone of the paper create the mysterious silhouette of the eucalpytus trees. He has delicately drawn in the sky with just a hint of clouds and the moon on the horizon, creating a moody and magical image of the night. It is interesting that Maurice Braun, another artist associated with the Theosophical Society, also produced a large number of crayon drawings, although he rarely used darkly toned paper.

Works in collection:
6 oils, 2 watercolors,
200+ drawings and sketches,
archival material

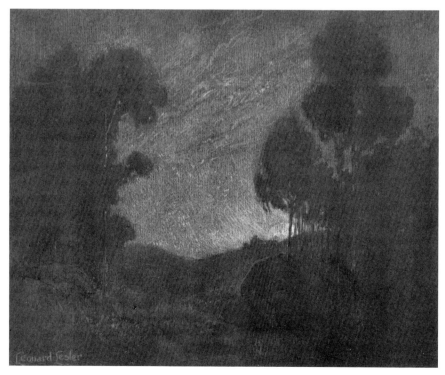

Maurice Braun

born: Nagy Bittse (near Budapest), Hungary, October 1, 1877
died: San Diego, California, November 7, 1941

Braun arrived in the United States at the age of four when his parents settled in New York City. Showing an interest in art at an early age, Braun enrolled at the National Academy where he studied from 1897 to 1900. During 1902 and 1903, he visited art centers in Berlin and Vienna. Braun had developed an interest in Theosophy while in art school and this led him to move to San Diego in 1909. Although he never actually joined the Lomaland community as a resident, Braun became an active member of the Theosophical Society. Katherine Tingley gave him studio space in the Isis Theater building in downtown San Diego and he founded the San Diego Academy of Art at that location in 1910.

Braun's national reputation was enhanced by gold medals at the San Diego and San Francisco expositions of 1915. During the 1920s, Braun maintained studios in New York and Connecticut as well as San Diego. He became one of the original members of Contemporary Artists of San Diego founded in 1929. The Depression years were very hard on Braun, and his interest in oriental philosophy was renewed during these difficult times. In the early 1930s, he became a member of the Theosophical Cabinet and in 1937 he was named head of the art department of the Theosophical University. He received the honorary title of "dean" of San Diego painters after the death of Charles Fries in 1940.

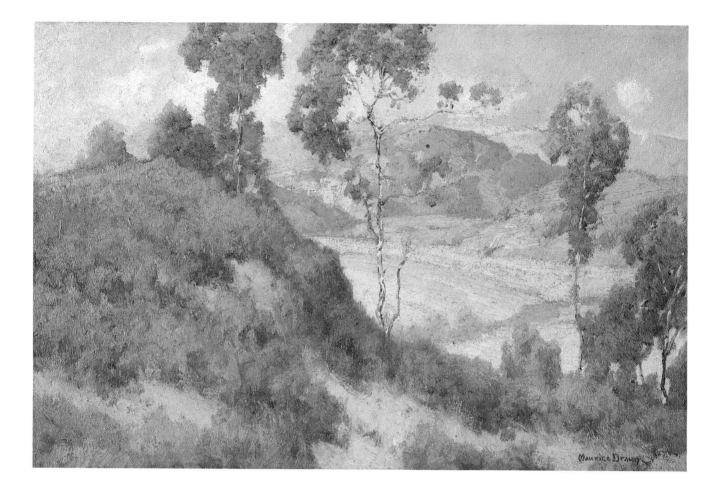

14. Landscape, San Diego Backcountry (ca. 1915)
oil on canvas, 12" x 18"
signed lower right
Gift of Mary Louise Lloyd (1982.46)

Typical of Braun's work, this landscape exhibits his distinctive short brushstrokes and color palette, with its tendency toward purple-blues, olive greens and russets. From the foreground shadows, he leads the viewer through a screen of delicate eucalyptus trees to a brightly lit field and stream with mountains beyond. Braun's work has none of the didactic qualities found in the paintings of some of the other Theosophical artists, but displays a certain calmness and mystery that demonstrate an interest in "hidden" qualities. Braun once wrote "Artists cannot afford to disregard Theosophy, because it develops the very qualities which are absolutely necessary in their make-up, namely, their true manhood, the power of imagination, an insight into nature and into spiritual truths."

The donor's father, Weldon Foster Lloyd, was a Theosophist with an interest in art. He owned a painting by a Scottish artist which Braun admired so they traded for this painting. The donor and her brothers all attended school at Lomaland.

Works in collection:
2 oils

Arthur Putnam

born: Waveland, Mississippi, September 6, 1873
died: near Paris, France, May 27, 1930

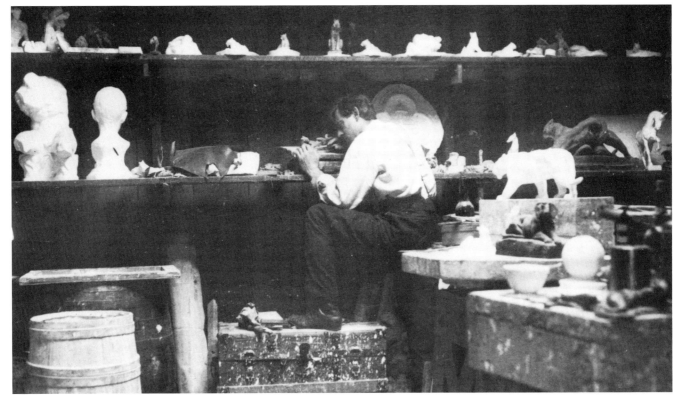

Putnam spent much of his youth in Nebraska where he experimented with sculpture in pipe clay and sandstone. Following his mother to the San Diego backcountry in 1891, he attempted a homestead without success. He traveled to San Francisco where he studied at the Art Students' League and learned the basics of sculpture working as an assistant to Rupert Schmid. Returning to San Diego, he continued studying on his own and developed a keen interest in portraying the animals of the wild in a vivid style. He briefly studied with the animal sculptor Edward Kemeys in Chicago but returned to California to marry in 1899. Establishing a studio in San Francisco, Putnam worked in extreme poverty until he began to obtain some commissions for architectural ornamentation. In 1903, he received a major commission to produce a series of large bronzes for Edward W. Scripps. Spending most of 1906 and 1907 in Italy and France, he had work accepted for Salons in both Rome and Paris. Returning to San Francisco, Putnam became involved in the rebuilding of the city after the disastrous 1906 earthquake. Tragically, surgery to remove a brain tumor in 1911 ended his career as a sculptor. Though handicapped, he was elected to membership in the National Sculpture Society in 1913, had four of his pieces included in the Armory Show in New York that same year, and won a gold medal at the 1915 San Francisco exposition. In 1921, he moved to Paris where he spent his final years.

15. Indian (1904)
bronze, 104" high
signed and dated at rear of base
Gift of the descendants of Edward W. Scripps
(1976.11.1)
(illustrated on back cover)

16. Combat: Man, Horse, Bear (1910)
plaster, 15 3/4" high
signed and dated beneath bear
Gift of Robert S., Edward S., and Thomas M. Meanley
(1985.73)

In 1903, newspaper magnate Edward W. Scripps commissioned Putnam to produce a history of California in monumental sculptures to decorate Miramar Ranch. Putnam originally envisioned the sculptures in granite, but abandoned this idea in favor of bronze. Scripps agreed to pay $100 per month while Putnam worked on the project and gave the sculptor almost complete freedom, writing "I am sure that whatever influence I would exercise would be a bad influence on art." Although the two did not always agree, they developed a mutual respect and admiration, and Scripps later wrote "There is some satisfaction in the thought that each of us needed the other to create a result."

Indian, the first figure for the Scripps project, remains the largest free-standing sculpture Putnam ever completed. It was modeled in San Francisco in the hull of one of the ships abandoned during the Gold Rush. As the bay filled in, these landlocked vessels were converted to other uses and Putnam established a studio in one. The bronze was cast at the Globe Brass and Bell Foundry in San Francisco. J. Mayne Baltimore, writing in the November, 1905, issue of *The Craftsman*, felt that unlike the popular theatrical conceptions of Indians, Putnam's figure "...represents an Indian who typifies, as unconsciously as a forest animal, the native poise and dignity of mind, as well as the grace and strength of body, of man untrammeled by civilization."

Before departing for Europe in December of 1905, Putnam had started to work on some of the other figures. Among those discussed with Scripps were an Indian woman at her grinding stone, a trapper, a prospector, a military man and a Spanish padre. Returning from Europe in 1907, the sculptor discovered that his studio had been destroyed in the 1906 earthquake and fire, forcing him to start over. He built a new studio and there completed the second figure for the project, *Padre* (1908). The third figure was to be a Mexican woman on a rearing horse, but this was postponed while Putnam completed *Ploughman* (1910). For Mrs. Scripps, he also created two life-size pumas and a fountain incorporating four figures of children playing with animals for the courtyard at Miramar Ranch.

Scripps expressed some apprehension about the Mexican figure. "Now as to our other subject — 'The Lady Vaquero.' This subject will require heroic treatment to save it from the curse of absurdity." He feared it would not harmonize with the other figures. The Historical Society's plaster model of a vaquero on horseback being attacked by a bear was offered by Putnam as an alternate concept, but Scripps was still uncertain. "With three figures in the piece — the human one being in nature the smallest — I am bound to suppose that even at life/size the whole would be a rather large mass of bronze."

Unfortunately, Putnam's surgery in 1911 prevented

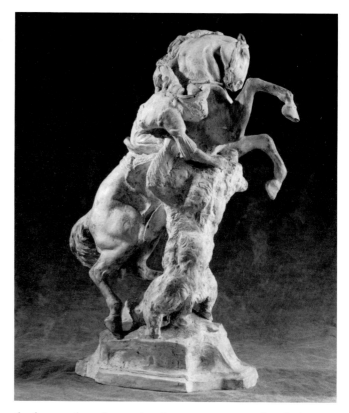

further work and no other bronzes were completed. Scripps had a great deal of faith in Putnam's ability and potential, and was deeply saddened by the sculptor's incapacitation. After Scripps' death in 1926, the bronzes remained at Miramar Ranch until 1933 when *Indian* and *Padre* were loaned to the San Diego Historical Society by the E. W. Scripps Trust and placed at Presidio Park. They were donated to the Society by the descendants of E. W. Scripps in 1976. *Ploughman* was placed at Scripps Institution of Oceanography in La Jolla.

No longer able to work, Putnam moved to Paris in 1921 to supervise the casting of two large sets of his bronzes for Mrs. Adolph B. Spreckels. She presented one set to the Fine Arts Gallery in San Diego, and the other to the California Palace of the Legion of Honor in San Francisco. Scripps must have allowed the sculptor to borrow this plaster, because bronze casts of it exist in the collections of both the San Diego Museum of Art and the Fine Arts Museums of San Francisco. The plaster original passed to Scripps' daughter, Nackey S. Meanley, and was donated to the Historical Society by her sons.

Works in collection:
5 bronzes (2 recast), 3 plasters

Allen Hutchinson

born: Stoke-on-Trent, Staffordshire, England, January 8, 1855
died: London, England, July 28, 1929

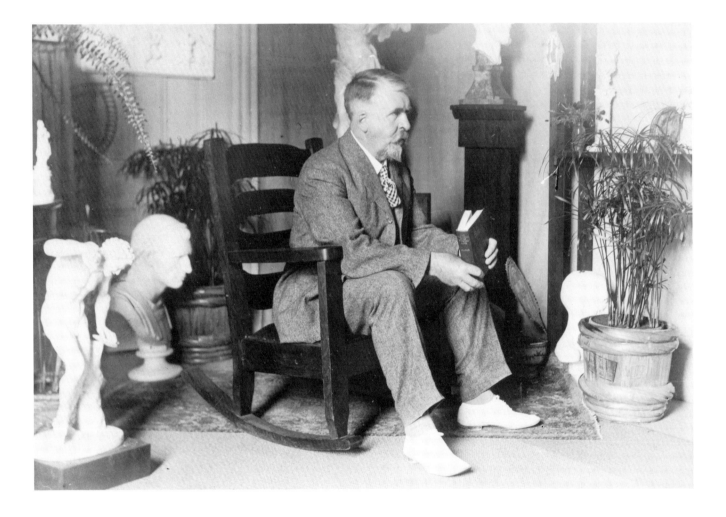

After a youthful stint in the British Navy, Hutchinson returned to London in the 1870s to study sculpture under Edouard Lanteri. In the early 1880s he began exhibiting at the Royal Academy. He traveled to Paris, Berlin, Naples and Rome for additional studies. Developing an interest in racial types, Hutchinson journeyed to Canada in 1886 to study the Indians of North America. After a brief visit to California, he continued on to Hawaii where he made busts of King Kalakaua and Robert Louis Stevenson. He also worked in Australia and New Zealand before returning to the United States in 1902. After assisting with the sculpture for the 1904 St. Louis World's Fair, he settled in San Diego in 1906 and obtained an appointment as British Vice-Consul. While in San Diego he made models for a proposed 150 foot tall statue of Cabrillo. After the death of his wife in 1915, he left San Diego and set up a studio in New York. In 1928 he returned to England where he died the following year.

17. Alonzo E. Horton (1906)
bronze, 26" high
signed and dated on rear of left shoulder
Cast in bronze for the Society with funds provided by
the Faye Dobbs Gonzales Foundation
(1980.52)

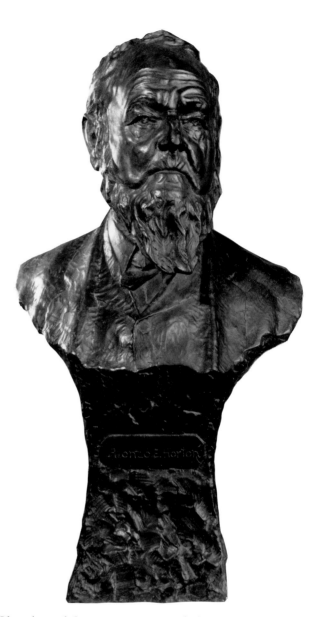

When Hutchinson moved to San Diego in 1906, Alonzo Horton was 92 years old, but still in good health. George Marston and several other prominent citizens asked Hutchinson to create a bust of Horton as a permanent memorial of San Diego's chief modern historical figure (see also catalogue numbers 2 and 25). Hutchinson modeled the bust from life in November of 1906 and efforts were made to raise the $600 necessary to pay the sculptor and have the piece cast in bronze.

The fundraising efforts went slowly and in August of 1908, a second attempt was made to obtain the needed funding. The bust was placed on exhibit at the Bank of Commerce downtown and an article in the *San Diego Union* reported that "So much interest has been displayed in the new portrait bust of 'Father' Horton...that it will be an easy matter to secure, by voluntary public subscription, sufficient funds to purchase it and place it eventually in the new City Hall." The campaign, however, remained unsuccessful.

Another attempt was made on December 24, 1908, when a committee comprised of Mayor John F. Forward, Alice Klauber, and George W. Marston sent a printed letter with a photograph of the bust to prospective donors asking for contributions. The letter stated "Mr. Horton is so advanced in years that it is quite improbable that he will ever sit for another portrait, and, most fortunately, the character of Mr. Hutchinson's bust renders this entirely unnecessary." The committee hoped to officially present the bust to the City on New Year's day, a few days later.

Horton died on January 7, 1909, and a notice in the *San Diego Union* of January 12 made yet another appeal. This time, the article listed the price as $750 and stated "This bust is declared by intimate friends of the Horton family to be a splendid likeness of the famous pioneer, and at the same time is pronounced by several artists to be a real work of art." Unfortunately, not even Horton's death provided the necessary incentive to successfully complete the campaign. Although the list of donors includes the names of many of San Diego's most prominent citizens, only $375 was raised and the efforts were abandoned.

The Horton bust remained in San Diego and it seems likely that the money which had been raised was used to purchase the original plaster from the sculptor in the hope that some day the bronze casting could be accomplished. The Chamber of Commerce acquired the original bust and donated it to the San Diego Pioneer Society. Presumably it became part of that group's historical display in Balboa Park. When the Pioneer Society donated its collection to the San Diego Historical Society in 1930, the Horton bust was included in the gift. Too fragile to be placed on public display, it remained in storage until rediscovered by Horton's biographer, Elizabeth MacPhail, when she was researching an article about Hutchinson. The bust was finally cast in bronze in 1980 in an edition of two. Hutchinson's original plaster remains in the collection of the Historical Society.

Works in collection:
1 bronze (cast 1980), 2 plasters

Mary Belle Williams

born: Massillon, Ohio, December 13, 1873
died: Los Angeles, California, June 21, 1943

Williams began her studies of art as a child. She moved to San Diego about 1906 with her father and brother who owned a gold mine in Julian. She was a member of the San Diego Art Association and frequently exhibited with the group. Her solo exhibition at the old Carnegie Library in 1909 was the largest ever held in San Diego up to that time. Her work received a silver medal at the Panama California Exposition in 1915, and her miniatures won a bronze medal at the exposition the following year. She seems to have left San Diego after the exposition and may have gone to New York to continue her art studies. Returning to San Diego about 1922, she re-established her association with the San Diego Art Guild of which she had been a charter member in 1915. Known primarily as a portrait painter, she exhibited a portrait of Hannah P. Davison at the California Pacific International Exposition in 1935. She remained active in San Diego until the last six months of her life which were spent in a hospital in Los Angeles.

18. San Diego Mission Ruins (ca. 1927)
oil on canvas, 20" x 24"
unsigned
Anonymous gift (1984.72.7)

The ruins of the San Diego mission were in a sad state by the end of the 19th century (see also catalogue numbers 4 and 6). In 1900, the Landmarks Club provided some money to stabilize the ruins under the direction of architect William S. Hebbard. Efforts to restore the mission church were made in 1911 and again in 1919, but little was accomplished. In 1927, the Mission Restoration Committee, headed by Albert V. Mayrhofer, began a major campaign to raise money for a complete restoration which began on July 16, 1930, the 161st anniversary of the mission's founding. The completed structure was rededicated on September 13, 1931.

Williams has depicted the front of the last remaining corner of the mission compound just prior to its final restoration. The vivid colors of this rapidly painted sketch are typical of the artist's work. A comparison with historical photographs helps date the painting and shows that she has accurately captured the condition of the ruins in the late 1920s. They also show that Williams has taken certain liberties with the scene, eliminating several obvious modern intrusions including a bell stand and bell on the wall to the left of the facade and some wooden beams used to prop up the walls to the right. In the romantic spirit, she preferred to show the ruins in quiet, abandoned desolation.

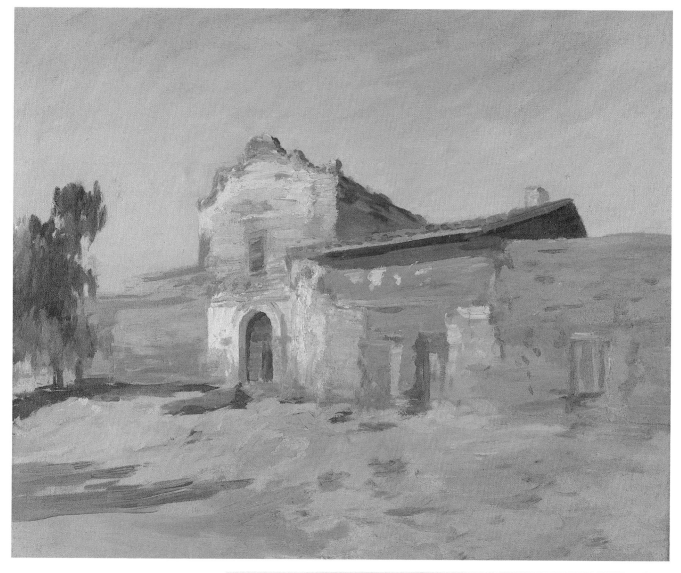

Works in collection:
2 oils, 1 pastel

Photograph of
San Diego Mission
dated
July 21, 1927

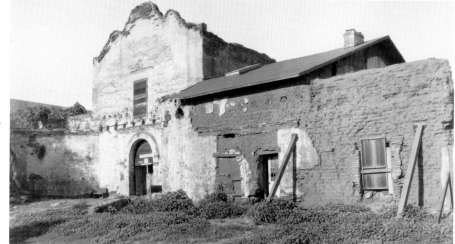

Harry Cassie Best

born: Mt. Pleasant, Ontario, Canada, December 22, 1862
died: San Francisco, California, October 14, 1936

Best and his brother Arthur, who also became an artist, played in a band that traveled west to Portland, Oregon, where Harry first began painting. In 1895, he moved to San Francisco where he drew cartoons for the *San Francisco Post*. A trip to Yosemite in 1900 impressed him so much that he moved there, opening the Best Studio as a Yosemite concession in 1902. On his way to spend six months in Europe in 1907, Best held an exhibition in Washington, D.C., where his painting *Evening at Mt. Shasta* was purchased by President Theodore Roosevelt. In 1910, Best held an exhibition at the U. S. Grant Hotel in San Diego. He began to winter in San Diego, and built a studio and bungalow on Fifth Avenue. His painting *Ramona Going Through the Wild Mustard* was exhibited in Old Town at Ramona's Marriage Place (the Casa de Estudillo) in 1911. He traveled and painted in Hawaii in 1916 and 1920, and his paintings of the eruption of the volcano Kilauea received much comment. Best maintained his studio in San Diego until at least 1926, and exhibited locally until the early 1930s. Best's daughter married photographer Ansel Adams and after the painter's death, the Best Studio in Yosemite became the Ansel Adams Gallery.

19. Winter, Yosemite, 1851 (ca. 1905)
oil on canvas, 30" x 44"
signed lower right
Gift of Mr. & Mrs. Joseph E. Jessop, Sr. (1978.7.2)

Best here recreates a scene of the Indians' final winter in Yosemite Valley. The Gold Rush brought miners to the Indian lands and in an attempt to drive them away, the Indians began to raid the trading posts in the foothills. In March of 1851, the state-sanctioned Mariposa Battalion, led by Major James D. Savage, became the first group of non-Indians to enter the valley. By force of arms they removed the natives from their stronghold and took them to a reservation. Although they were of the *Ah-wah-ne-chee* tribe, the other native groups in the area called them *U-zu-ma-te*, the Indian word for grizzly bear. Accompanying the battalion was a surgeon, Dr. Lafayette Bunnell, who named the valley "Yosemite" after this Indian word.

"Winter" Yosemite represents the end of the Indians'

traditional way of life in Yosemite Valley. The bleakness of the winter landscape is offset by the figures going about their daily chores. In the background, teepee-shaped dwellings made of poles and incense-cedar bark, underscore the temporary nature of the Indians' nomadic existance.

Joseph Jessop, father of the donor and founder of J. Jessop & Sons, Jewelers, was a friend of the artist and purchased this painting and a companion piece for his home in Coronado. The companion piece, of identical dimensions, is dated 1905, and depicts the Yosemite Valley in summer, but without figures. Jessop probably purchased the paintings soon after they were completed and certainly before January 1914 when he was listed among owners of paintings in an article about Best by George Wharton James published in *Out West*.

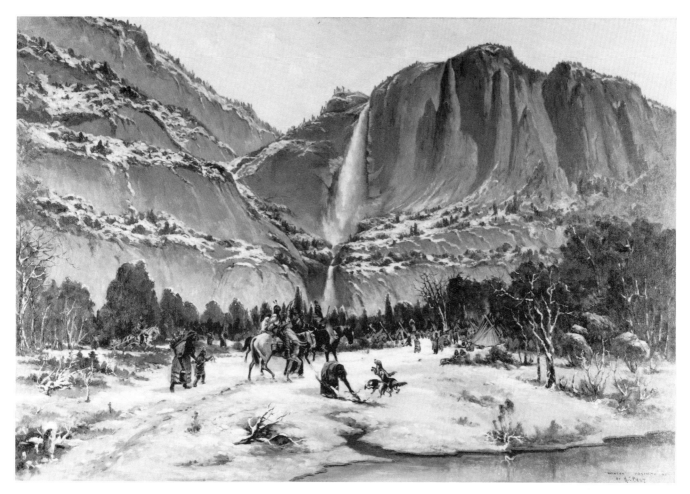

Works in collection:
2 oils

Detail of above

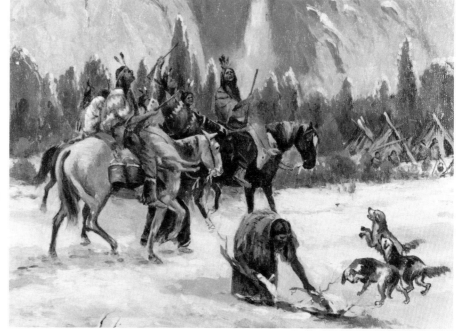

Albert Robert Valentien

born: Cincinnati, Ohio, May 11, 1862
died: San Diego, California, August 5, 1925

Valentien received his early art training under Prof. Thomas G. Noble at the School of Design of the University of Cincinnati where he began at age thirteen. This school later became the Cincinnati Art Academy which he continued to attend, studying with Frank Duveneck. Valentien worked for the early Coultry and Wheatley potteries in Cincinnati and also taught one of America's first classes in decorative art pottery. In 1881, the Rookwood Pottery hired him as the first regularly employed member of their decorating staff and eventually chief decorator. Rookwood sent him to Europe in 1894 to study European pottery manufacturers and again in 1899 to supervise the Rookwood exhibit for the Paris Exposition of 1900. Here Rookwood received the Grand Prix in pottery and Albert was awarded a gold medal for his contributions. He also had one of his paintings accepted for the Paris Salon that year. His first visit to San Diego in 1903 was prompted by reports of the local wildflowers, since flower painting had become a special interest of his. He left Rookwood in 1905 and three years later moved to San Diego. Soon afterwards, Ellen Browning Scripps commissioned him to paint the wildflowers of California, a project which went to 1100 sheets and took years to complete. He also did work for the San Diego Floral Association including the cover design for their magazine *California Garden* and designs for their award medals. In 1921, he served as president of the San Diego Art Guild.

20. Landscape, Mesa Grande (ca. 1920)
oil on board, 23" x 19"
unsigned
Anonymous gift (1986.81.3)

Although Valentien is known primarily for his studies of flowers in opaque watercolors, this painting demonstrates that he was also a proficient painter of landscapes in oils. He has created an interesting composition of horizontal bands in a vertical format with a single California Live Oak as a focal point. By using a high horizon line and contrasting the pale blues of the mountains with the deep greens of the foreground foliage he achieves a feeling of great distance.

Valentien painted this and several other Mesa Grande landscapes while staying at Edward H. Davis' Powam Lodge.

Davis, himself an artist, recorded southwest Indian life in articles and photographs and collected Indian artifacts for the Museum of the American Indian, Heye Foundation, New York. Designed by Emmor Brook Weaver in 1914, Powam Lodge burned to the ground in 1929 destroying much of Davis' collection of artifacts. Other artists stayed and painted at the lodge including Maurice Braun.

Works in collection:
2 oils, 2 watercolors, 1 drawing

Anna Marie Valentien

born: Cincinnati, Ohio, February 27, 1862
died: San Diego, California, August 25, 1947

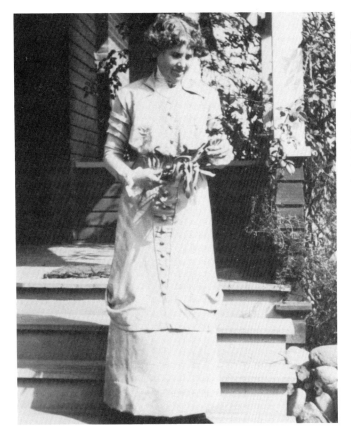

21. Albert R. Valentien (1900)
bronze medallion, 6 3/8" diameter
signed on shoulder
Gift of Mavina McFeron (1980.45.7)

After initial studies at the McMichen University School of Design, Anna worked with the craftsman Benn Pitman in Cincinnati. In 1884, she accepted a position as a decorator for the Rookwood Pottery where she met Albert Valentien whom she married in 1887. While working for Rookwood, Anna enrolled at the Cincinnati Art Academy where she studied with Frank Duveneck and Louis T. Rebisso. In 1893, she displayed her life-size figure of *Ariadne* at the Columbian Exposition in Chicago, and her life-size *Hero Waiting for Leander* won a gold medal at the Atlanta Exposition of 1895. Accompanying her husband to Paris in 1899, she studied at the Academy Colorossi and also at the Academy Rodin. One of her pieces was accepted for the Paris Salon in 1900. Moving to San Diego in 1908, she and her husband briefly operated a pottery company for which she produced some sculptural pieces. In 1914, she turned to teaching crafts and sculpture through the local schools and among her most prominent students were Dorr Bothwell and Donal Hord. At the 1915 San Diego exposition she received a gold medal, and the following year she received two additional gold medals. In 1926, she traveled to the Santa Barbara School of the Arts where she studied bronze casting. During the late 1920s she again turned her interest to painting, continuing her studies under Otto Schneider at the San Diego Academy of Fine Arts, and won several awards.

22. San Diego Gas Works (ca. 1930)
oil on masonite, 16" x 20"
signed lower left
Gift of Mavina McFeron (1980.45.3)

Anna Valentien produced this profile portrait of her husband (see catalogue number 20) while the couple was in Paris preparing for the exposition of 1900. Albert had been sent there to supervise the Rookwood Pottery exhibit for the fair and Anna accompanied him to augment her art studies at the famous art schools of that city. She enrolled at the Academy Colorossi, studying with Jean Antoine Injalbert, and also at the Academy Rodin under Emile Bourdelle, Jules Des Bois, and August Rodin himself. A personal note from the master was one of her treasured mementos. This sand-cast relief portrait is an excellent likeness and received the honor of being accepted for the Paris Salon in the spring of 1900.

Although she had studied painting under Frank Duveneck at the Cincinnati Art Academy early in her career, Valentien did not return to oil painting until later in life. According to the donor, the artist's grandniece, she did not want to be in a position of competing with her husband in juried art exhibitions, so did not actively turn her attention to painting until after his death in 1925. At the age of sixty-five, she enrolled at the San Diego Academy of Fine Arts and took additional instruction in painting from Otto H. Schneider.

Interest in painting industrial scenes increased during the new industrial age of the 1920s and 1930s. San Diego never became a major manufacturing center so local artists

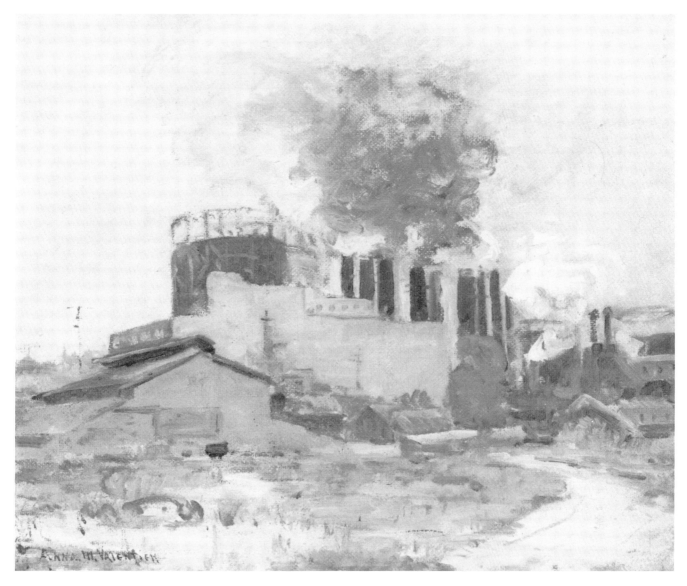

wishing to paint large factory buildings did not have many options. Valentien selected the plant of the San Diego Gas Works at Tenth and Imperial avenues for this scene painted on a typical overcast day. She has recorded the appearance of the original small structure in the foreground built in the 1880s, the smokestacks of the Station A building which was in operation from 1924 to 1938, and the large storage tanks constructed in 1923 and not dismantled until 1969. Her technique is dry and sketchy, and shows the influence of Otto H. Schneider (see catalogue number 36). The belching smokestacks add a note of drama to the composition.

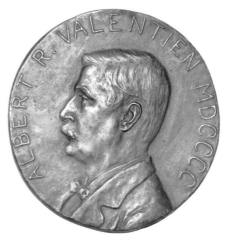

Works in collection:
4 oils, 1 bronze, 3 plasters, 100+ sketches, misc. craft items including copper, baskets, leather, etc.

Alice Klauber

born: San Diego, California, May 19, 1871
died: Lemon Grove, California, July 5, 1951

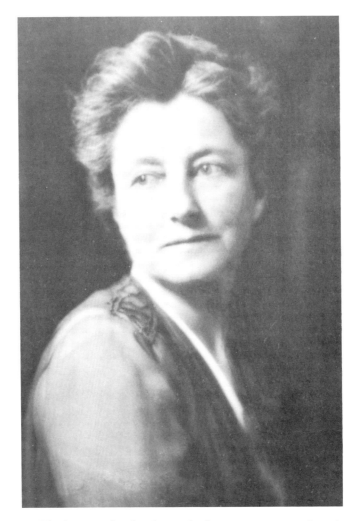

San Diego's first native artist, Klauber was the daughter of a prominent merchant who moved to San Diego in 1869. From 1885 to 1892, Alice attended school in San Francisco and began her art studies at the Art Students' League of that city. Later, her studies included painting under Hans Hofmann and William Merritt Chase. In 1907, she studied with Robert Henri in Spain. Named chairman of the art department for the 1915 San Diego exposition, Klauber convinced Henri to visit San Diego in 1914. They organized an exhibition of some of America's foremost contemporary artists for the fair. Klauber was affiliated with a number of art organizations and was one of the main forces behind the founding of the Fine Arts Society and gallery in 1926. She had a strong interest in oriental art and helped found the gallery's Asiatic Arts Committee. Exhibiting frequently in southern California, she had pieces accepted for both the 1916 and 1935 expositions in San Diego. In addition to her painting, she designed the interiors of the Persimmon Room for the 1915 fair, the Community Center in Balboa Park, the Y.W.C.A. and the Wednesday Club. Bookplates of her design could be found in many of San Diego's most prominent private libraries. In 1928, Denrich Press in Chula Vista published a book of her poems. Alice Klauber was one of the major forces behind the cultural advancement of San Diego during the first half of this century.

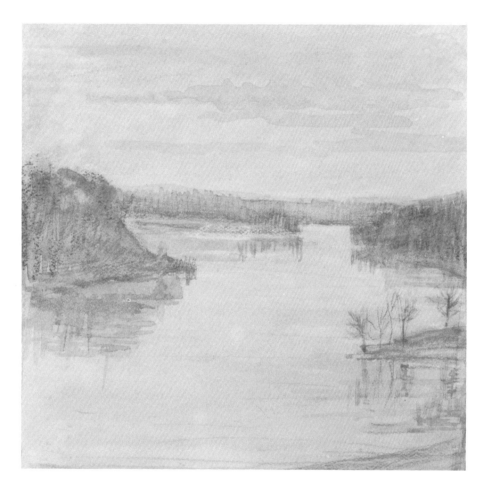

23. Kaukauna (1903)
watercolor, gouache and crayon,
4 1/2" square
unsigned
Gift of Bill Lykke (1986.83)

In the spring and summer of 1903, Alice Klauber traveled extensively in Wisconsin and northern Illinois while studying art in Chicago. The Historical Society owns a number of sketches and small watercolors done near Kaukauna, a town on the Fox River between Lake Winnebago and Green Bay, Wisconsin. Some of these studies are carefully coded with color notations as if in preparation for a larger composition, and Klauber's journal from this period makes several mentions of her working on a "large canvas." The present whereabouts of this work is not known. In this tiny study, the artist has created a beautiful image of the marshy area capturing the subtle colors in a soft but vivid style.

Works in collection:
2 oils, several small sketches, archival material

Annie Pierce

born: San Diego, California, October 28, 1877
died: San Diego, California, August 31, 1951

Annie was one of San Diego's first native artists. Coming from an artistic family, she studied art from childhood and was a protege of Cora Timken (Burnett). Taking an early interest in the local art scene, she was among those who signed the by-laws of the San Diego Art Association at its incorporation in 1904. She exhibited two of her pastels at the group's first exhibit in the old Carnegie Library, downtown San Diego, in 1905. Pierce belonged to the San Diego Art Guild and may have joined at its founding in 1915. Her work was included in the art exhibition at the 1916 exposition in San Diego. She exhibited locally and also in New York and Boston. During the 1935 exposition, she shared a studio in Balboa Park with Alice Klauber and had one of her watercolors accepted for the official art exhibition. A stroke in 1944 prevented further artwork. In 1952, a memorial exhibition at the Fine Arts Gallery included portraits, landscapes and flower pieces in oil, watercolor, pastel and block printing.

24. Alice Klauber at Her Easel (1901)
watercolor, 11 3/4" x 8 3/4"
signed and dated lower right
Gift of the Estate of Leda Klauber (1981.54.2)

Alice Klauber (see catalogue number 23) and Annie Pierce were good friends who shared a studio several times during their careers. Pierce here captures a candid view of her friend busy at a large easel, her back turned to the viewer. The painting becomes an interesting period piece with Klauber's high collared blouse and long blue dress protected by an apron. Details of the studio interior are only slightly sketched in and the entire composition is treated with refreshing spontaneity.

Works in collection:
1 watercolor, 1 drawing

Felix Achilles Peano

born: Parma, Italy, June 9, 1863
died: Hawthorne, California, January 10, 1949

Peano began his art education in Turin, Italy, where he studied at the Academy Albertina. Later studies took him to Rome and Paris, and he also taught at various schools in Europe. By the 1890s, he had arrived in the San Francisco Bay Area where he joined the San Francisco Art Association and taught at the Mark Hopkins Art Institute. In 1905, he began working on twelve decorative bridges for Venice, California, which were covered with sculptured serpents and sea creatures. Peano's earliest known project in San Diego was the creation of an eagle and three portrait relief panels for the electric fountain in Horton Plaza which was dedicated

in 1910. He produced decorative relief panels for the United States National Bank at Second and Broadway in 1912 and almost certainly did some of the detail work on the interior of the Spreckels Theater. Peano listed himself in the San Diego directories from 1914 to 1922, but few projects from his hand are known. He spent the later part of his career in the Los Angeles area where he produced the interior decorations for St. Vincent's Church. His house in Hawthorne was filled with fanciful sculpture and other architectural embellishments.

25. Alonzo E. Horton (1910)
bronze relief plaque, 16 1/2" x 12"
unsigned
Donor not recorded (1900.4.2)

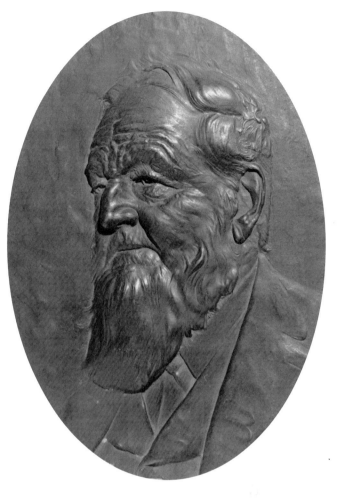

When Alonzo Horton (see catalogue numbers 2 and 17) decided to built a large hotel on D Street (now Broadway), he set aside part of a block directly across the street for a public plaza. This remained his property until 1894 when he sold it to the city. The Horton House hotel was demolished in 1905 to make room for the new U. S. Grant Hotel. In 1909, the Park Board asked Irving Gill to come up with a design for the plaza that would provide a more attractive compliment to the new hotel and allow for a central monument or fountain. Louis Wilde, who had a major financial interest in the hotel, offered to donate $10,000 for a fountain and a competition was held. Among the competitors were Allen Hutchinson (see catalogue number 17), Irving Gill, Arthur Stibolt, Lionel Sherwood, and F. C. Wade.

The Park Board selected Gill's design in November of 1909. Gill styled his design after the Choregic Monument of Lysicrates, a small masterpiece of Greek architecture erected in Athens in 334 B.C. and still standing. The fountain was made of granite, marble, bronze and prismatic glass with fifteen colored lighting effects each lasting thirty seconds. It was considered by many to be the first successful combination of colored lighting and moving water. The U. S. Grant Hotel was dedicated on October 15, 1910, and the electric fountain was unveiled that same day. The plaza was officially named Horton Plaza in 1925.

Peano obtained the commission to produce the sculptural ornamentation for the fountain which included an eagle preening its feathers above the inner dome and three portrait relief plaques around the base. These plaques carried the features of San Diego's three most important historical figures, Juan Cabrillo facing west, Alonzo Horton facing south, and Junipero Serra facing east. The Historical Society's relief plaque is identical to the one on the fountain base except that it is oval in shape. Apparently, this was an early attempt that did not cast completely and was therefore cut into an oval and turned into a wall hanging.

Works in collection:
1 bronze plaque

Alfred R. Mitchell

born: York, Pennsylvania, June 18, 1888
died: San Diego, California, November 9, 1972

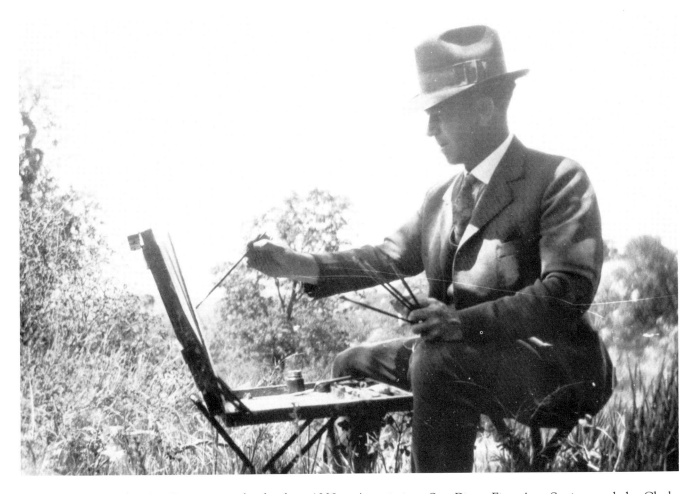

Mitchell moved to San Diego to join his family in 1908. After working in the family restaurant for a few years, he entered the San Diego Academy of Art to study with Maurice Braun in 1913. Mitchell's talent developed quickly and in 1915, he won a silver medal at the Panama-California Exposition. Encouraged by this award, he enrolled at the Pennsylvania Academy of Fine Arts in 1916, where he studied with Daniel Garber and Hugh Breckenridge. While at the academy, Mitchell received a Cresson European travel scholarship and spent the summer of 1921 in England, France, Italy and Spain. After returning from Europe, Mitchell established a studio in San Diego, but frequently took painting trips throughout the United States and Canada. Mitchell was instrumental in the establishment of several art organizations including the La Jolla Art Association, San Diego Fine Arts Society and the Chula Vista Art Guild. He became one of the original members of Contemporary Artists of San Diego in 1929 and served as secretary and treasurer for the group. One of the area's most sought after teachers, he exhibited frequently across the country and often won awards and critical praise. After the death of Elliot Torrey in 1949, Mitchell became known as the "dean" of local painters.

26. Coldwater Canyon, Arrowhead Hot Springs
(ca.1914)
oil on canvas, 28" x 31"
signed lower left
Anonymous gift (1981.81.3)

The reverse of this painting is inscribed "S. D. Academy of Art" indicating that Mitchell painted it while still a student of Maurice Braun. Braun's influence is strong, but particularly noticeable in the short brushstrokes and color tonalities with their tendency to olive greens and golden browns. Mitchell painted a watercolor of this composition on site in the San Bernardino Mountains and then completed the finished work in this studio. The original watercolor is also in the Historical Society's collection.

Coldwater Canyon was accepted for exhibition at the Panama-California Exposition of 1915 where it received a silver medal. Although the majority of paintings displayed at the fair did win medals, this was still a significant award for the aspiring young artist. Among the other silver medal winners with whom Mitchell was favorably grouped were Carl Oscar Borg, Helena Dunlap, Hanson Puthuff, Donna Schuster and Max Wieczorek. This award no doubt affected Mitchell's decision to pursue a career in art and enter the Pennsylvania Academy. Mitchell's silver award medal was donated to the Historical Society by the artist's niece in 1987.

27. Flower Show in Balboa Park
(ca. 1925)
oil on canvas, 18" x 20" unsigned
Gift of Dorothea W. Mitchell
(1979.21)

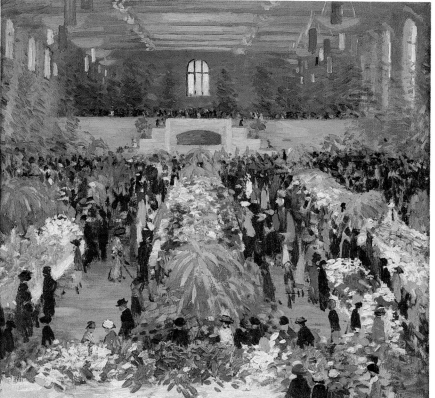

After the close of the Panama-California International Exposition of 1916, many of the buildings remaining from the fair were put to other uses. The former Southern Counties Building was converted for use as the city's first municipal auditorium. It held different functions and was the site of this flower show recorded in one of Mitchell's most impressionistic paintings. He achieved the effect of abundant flowers and crowds of people using lively dabs of paint. The elevated perspective, lustrous color and roughly sketched figures make this one of his most vibrant and spontaneous early works.

Dating of the painting is helped by the fact that the building burned to the ground on the evening of November 25, 1925. That night it was to be the site of the annual Fireman's Ball, but the firemen where at home getting ready when the blaze started. The San Diego Natural History Museum was later constructed on the site.

Works in collection:
35 oils, 1 watercolor, 19 drawings, 1 clay relief plaque, archival material

45

San Diego's Art Scene Comes of Age

With the opening of the Fine Arts Gallery in 1926, San Diego obtained a stature in the art world that it had previously lacked. San Diego finally had a handsome and appropriate building in which to assemble an important permanent collection of work by old and modern masters as well as a place to host traveling and competitive exhibitions. Two annual shows, the Exhibition of Southern California Art in the summer and the San Diego Art Guild in the fall, provided an opportunity for local and non-local artists to compete, display, and sell their work through juried exhibitions.

In 1927, George Marston helped establish the Interracial Committee of San Diego to "promote kindly and mutually helpful relations between all races." This group sponsored an Exhibition of Contemporary Negro Art at the Fine Arts Gallery in 1928 of which little record survives. The second annual exhibition, held in the fall of 1929, included works by major African-American artists from all over the United States as well as Henry Ossawa Tanner, the prominent American painter living in France. Several San Diegans exhibited paintings and craft work at the show. In 1930, the Negro Friends of the Fine Arts Gallery donated a sculpture by Sargent Johnson to the permanent collection.

By the late 1920s, a number of dedicated professional artists resided in San Diego. Eight of these met in the studio of Leslie W. Lee in 1929 and formed Associated Artists of San Diego. The other seven members were James T. Porter, president, Alfred Mitchell, secretary/treasurer, Maurice Braun, Charles Fries, Charles Reiffel, Otto H. Schneider and Elliot Torrey. Some local commercial artists were already using the name Associated Artists so the new group changed its name to Contemporary Artists of San Diego. They invited Aloys Bohnen, Leon Bonnet, Donal Hord and Everett Jackson to join them and all save Bohnen accepted. These nine painters and two sculptors began to hold exhibitions in San Diego and elsewhere and briefly operated their own gallery on Seventh Street downtown.

Another less-formal group began exhibiting together in the early 1930s under the name San Diego Moderns. Among its members were Dorr Bothwell, Donal Hord, Everett Jackson, Foster Jewell, Katharine Kahle (McClinton), Ivan Messenger, and Margot and Marius Rocle. They held their first exhibition at the Fine Arts Gallery in February of 1933. Although both Hord and Jackson were also members of Contemporary Artists, the San Diego Moderns were among the first local artists to challenge the concepts of traditional academic art.

As the Depression grew worse, artists were among those hardest hit. To remedy this situation, President Franklin D. Roosevelt established public art programs through the Works Progress Administration (W.P.A.) in order to employ artists and enhance public buildings. Many local artists including Charles Reiffel, Elliot Torrey and Charles Fries took advantage of these programs. Donal Hord created some of his finest public sculptures under the auspices of the W.P.A. In 1933, City Librarian Cornelia Plaister sponsored the first San Diego outdoor art mart on the library lawn to assist artists during this difficult time.

The Mexican mural movement which began in the 1920s helped to revive interest in this ancient art form and had an important impact on American artists of the 1930s. Several local painters such as Belle Baranceanu, Aloys Bohnen and Charles Reiffel made murals for local schools through the W.P.A. Curriculum Project. Businesses, churches and other private clients also commissioned mural work. Dorr Bothwell, Ramos Martinez, Jose Moya del Pino, and Eugene Taylor were among artists who produced murals in San Diego during the 1930s.

In 1935-36, San Diego hosted the California-Pacific International Exposition in Balboa Park. A major art exhibition took place in the Fine Arts Gallery, renamed the Palace of Fine Arts during the fair. This included portions of the permanent collection as well as sections on the art of the Southwest and a gallery devoted to San Diego artists. Additionally, Donal Hord received a gold medal, Belle Baranceanu a silver and Esther Barney a bronze for their other contributions to the fair.

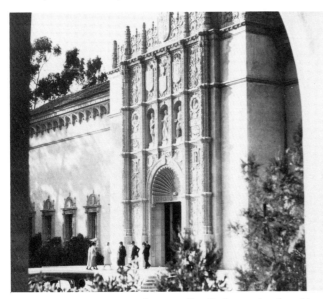

The San Diego Fine Arts Gallery in Balboa Park opened to the public in 1926.

A mock Spanish Village created for the fair reopened as the Spanish Village Art Center in April of 1937 and provided studio space for many local artists. A group called Los Surenos, founded in 1934 to preserve the early atmosphere of California, later evolved into the Los Surenos Art Center which moved to the Spanish Village when it opened. Martha M. Jones directed the group and Maurice Braun, Alfred Mitchell, Haidee Kenyon, Isabelle Schultz (Churchman) and Mary Belle Williams were among its members.

As the Depression ended and America marched into World War II, many local artists became involved in the war effort. Ruth Ball and Anna Valentien taught sculpture and crafts at the U.S.O. Isabelle Churchman became a draftsman for the 11th Naval District and Marian Lester did technical drawings for Ryan Aeronautics. Both Dayton Brown and J. Milford Ellison specialized in camouflage work and Belle Baranceanu created posters and murals for the war effort. Consolidated Aircraft hired a number of artists including John L. Stoner, Ethel Greene, Monty Lewis and James Clark. The University of California Division of War Research on Point Loma hired artists under the direction of John Olsen. At the war's end, they moved to the Naval Electronics Laboratory (N.E.L.). Barney Reid later directed the program at N.E.L. and Ethel Greene, Dan Dickey, and Ed Churchman were some of the artists he employed there.

After the war, Dan Dickey, Fred Hocks and Belle Baranceanu, who all had studios in the former Bishop's Day School on First Avenue, began to hold informal meetings with other art enthusiasts. From these meetings emerged the Allied Artists Council in 1946 with Lloyd Ruocco as president. The Council consisted of separate committees for painting, crafts, theater, music, dance, photography/film, writing and architecture. The council sponsored speakers including Man Ray and Aldous Huxley as well as a foreign film festival and fine arts ball. Although the council did not last long, one of the sub-groups, the Allied Craftsmen, remains active to this day.

In La Jolla, the former home of Ellen Scripps was purchased in 1941 and converted for use as the La Jolla Art Center. Two years later it was taken over for military use during the war. It reopened in 1944 and underwent extensive remodeling in 1951 and again in 1960 to allow for changing exhibitions, lectures and concerts. In 1971, the name changed to the La Jolla Museum of Contemporary Art and more recently to the San Diego Museum of Contemporary Art.

With the end of the war, returning veterans began to take advantage of local educational opportunities in the arts through the G.I. Bill. San Diego State College offered a fine program under the direction of Everett Jackson that included instruction from John Dirks, Lowell Houser, Ilsa Ruocco and

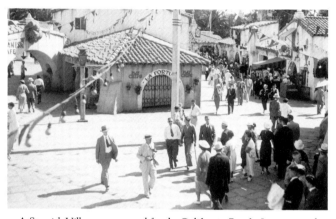

A Spanish Village constructed for the California-Pacific International Exposition of 1935-36 reopened as the Spanish Village Art Center in 1937, providing studio space for many local artists.

Jean Swiggett. Monty Lewis founded the Coronado School of Fine Arts in 1944 which offered a wide variety of classes in fine and commercial art. All instructors were practicing professional artists and four of them were Guggenheim Fellows. Instructors included Julia Andrews, Aloys Bohnen, Dan Dickey, Fred Hocks, Donal Hord and Margaret Price. In La Jolla, the San Diego School of Arts and Crafts, under the direction of Orren R. Louden, offered a varied art program taught by Belle Baranceanu, Fred Hocks and Ben Messick among others.

Although the San Diego Moderns had introduced progressive art concepts to San Diego in the early 1930s, it was not until after World War II that modern art began to assert itself in San Diego. Many exhibitions began to have separate sections for progressive and traditional work. A confrontation occurred at the spring exhibition of the San Diego Art Guild in 1948, when an abstract painting, *Hope Deferred* by John McLaughlin of Dana Point received top honors. A storm of controversy surrounded the award and resulted in letters to the newspapers and editorials regarding the merits and interpretation of this work and modern art in general.

Whether San Diegans liked it or not, modern art was here to stay. The recent war and anxiety of the atomic age prompted many artists to search for new and different modes of expression. In San Diego, Belle Baranceanu and Fred Hocks began to experiment with non-objective art. Ethel Greene and Jean Swiggett produced thought-provoking paintings with subjects outside the confines of reality. John Dirks created sculptural forms of abstract strength and dignity. Emerging young artists such as John Baldessari, Richard Allen Morris, Bill Munson and Sheldon Kirby became the new blood of San Diego's art community. These and other talented people helped move the San Diego art scene into the second half of the 20th century.

47

Leslie W. Lee

born: Manchester, England, March 26, 1871
died: San Diego, California, April 5, 1951

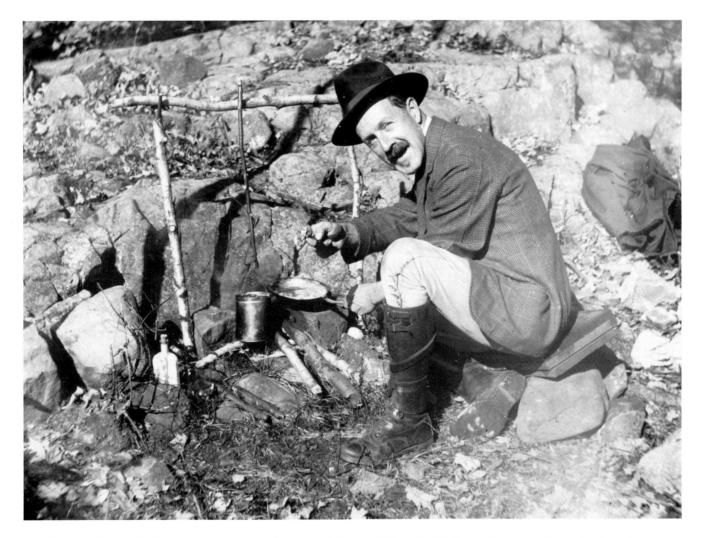

Born in England of American parents, Lee traveled across the Atlantic several times before his family settled permanently in Connecticut. Studies at the National Academy of Design and at the Art Students' League were followed by a period as a newspaper artist and cartoonist in New York. In 1899 Lee traveled to Europe where he studied at the Academy Julian. After returning to New York he became an instructor at the School of Applied Design in 1903. In 1909, Lee visited California and again traveled to Europe. The following year he made his first trip to Mexico which had a major impact on his work. He subsequently made several extended painting trips to Mexico and Central America. Lee and his wife, Melicent Humason Lee, who later became a prominent author of children's books, moved to San Diego in 1919, purchasing a ranch near Dehesa. They built a second studio and home closer to town on the south rim of Mission Valley in 1926. The first meeting of Contemporary Artists of San Diego was held in this house in 1929. In the 1930s, Lee became a member of the Grand Central Galleries in New York and had a one-man show there in 1936. The Depression was very hard on the Lees and they lost the San Diego studio and were forced to sell the ranch. After the death of his wife in 1943, Lee spent the remainder of his life in Encinitas and El Cajon.

28. El Mozo (ca. 1930)
oil on canvas, 22" x 18"
unsigned
Anonymous gift (1986.1.2)

In Spanish, *mozo* refers to a young man of the peasant class. On Lee's many trips to Mexico, he often sought out the native villagers in their colorful and picturesque serapes and sombreros to sit for paintings such as this. *El Mozo* is typical of Lee's bold style using very coarse canvas and large brushes loaded with rich color. He has captured this sitter's handsome face and direct gaze using the same spontaneous and vivid method found in most of this artist's work.

29. Peter Pan (1937?)
etching in sepia ink, 9" x 6" (image)
signed lower right margin (number 3 of 25 impressions)
Gift of Ivan and Evelyn Messenger (1982.38.3)

Ivan and Evelyn Messenger owned a cabin high above the desert at Kentwood-in-the-Pines, near Julian. Los Angeles artist Henri de Kruif was a good friend of the Messengers and named the cottage "Peter Pan" after the fictional hero in Sir James Barrie's play about a boy who never grew up. The Messengers and Lees were also good friends and frequently visited each other. This etching must have been done on one of their visits. The deeply etched foreground and carefully wiped plate create an image of rich contrasts and demonstrate that the artist's bravura style worked equally well with the etching needle as with the brush. It is odd that the artist addressed this print to his hosts in 1937 while the plate itself appears to be dated 1941 in the lower left corner.

Works in collection:
4 oils, 22 watercolors, 6 etchings

Donal Hord, N.A., F.N.S.S.

born: Prentice, Wisconsin, February 26, 1902
died: San Diego, California, June 29, 1966

Hord moved to San Diego with his mother in 1916 to get away from the Seattle climate where he had developed rheumatic fever. He began studying sculpture with Anna Valentien and by the age of sixteen started exhibiting his work. In 1926, he studied sculpture and bronze casting with Scottish artist Archibald Dawson at the Santa Barbara School of the Arts. A travel scholarship to Mexico in 1928 followed by study at the Pennsylvannia Academy of Fine Arts and Beaux Arts Institute in New York completed his formal training. In 1929 he became the youngest member of Contemporary Artists of San Diego. During the 1930s, he produced many important commissions for the W.P.A. His direct carving in diorite, jade, obsidian and tropical hardwoods brought him national recognition. The only local artist to become a full Academician of the National Academy of Design and a Fellow of the National Sculpture Society, Hord also received two Guggenheim fellowships and awards from the American Academy of Arts and Letters and the American Institute of Architects. A large figure for the American Battle Monuments Commission to decorate the American Cemetery at Henri-Chapelle, Belgium, became the most important commission of his career.

30. Culua (1930)
Mexican rosewood and mahogany, 13 3/4" high
unsigned
Gift of Alice Hastings Reed in memory of Mrs. Edgar F. Hastings (by exchange) and Mrs. Jane R. Rhodes (1979.3)

Hord had a well-established interest in ancient Mexico even before his first trip there in September of 1928. Early sculptures with titles such as *Tenochtitlan* (1919), *Chalchuihnenetzin* (1927) and *Ku-Kul-Kan* (1928), demonstrate the depth of his knowledge of these early cultures. Hord set out to create an art of the Americas based on American subjects and he even went so far as to use only native American hardwoods and stones.

Hord carved *Culua* (cool-wah) soon after his return from studies in Mexico, Philadelphia and New York. It seems likely that Hord here represents one of the Culhuas, the people that conquered the Toltecs and established the city of Culhuacan at the southern end of the Valley of Mexico in the 12th century. Culhuacan existed as a major power and

center of culture until civil war broke out at the end of the 14th century. The Aztec civilization entered the Valley of Mexico through Culhuacan, and eventually achieved dominance over the other city-states.

With an eye toward authenticity, Hord has carefully depicted the subject's lip plug and earrings. The thick braid of hair was designed to protect warriors against blows to the head. A small clay study for this piece, only 3" high, is in the collection of the San Diego Museum of Art. Hord exhibited *Culua* at the Painters & Sculptors of Southern California exhibition at the Los Angeles County Museum of Art in 1931 where it received the Merit Award, the first of many prizes the sculptor was to receive. A typographical error in the catalogue resulted in the misspelling of the title on the brass plate commemorating this award. Later in 1931, Hord exhibited *Culua* at the Exhibition of Southern California Art at the Fine Arts Gallery of San Diego along with *Noon* and *Young Maize*. The latter piece received the purchase prize, and the jury also awarded a special commendation on the group of three sculptures.

31. Study for Angel of Peace (1956)
plaster, 31" high
unsigned
Gift of Florence Hord and Homer Dana (1983.44.2)

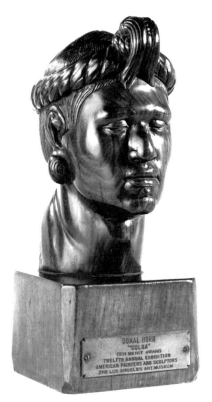

After World War II, the American Battle Monuments Commission was established by Congress to erect suitable memorials for the graveyards of American soldiers killed in battle. In January of 1956, Hord was contacted regarding a sculpture for the National Memorial Cemetery in Honolulu. At the same time, he submitted a portfolio of photographs of his work to the architects in charge of the memorial for Henri-Chapelle, Belgium, where the Americans who died during the Battle of the Bulge were interred. The Hawaii memorial was given jointly to Laura Fraser and Bruce Moore, but in July of 1956, Hord received word that he had been selected to create the figure for Belgium.

The Henri-Chapelle commission had originally been awarded to Carl Milles who died in 1955. Milles had made a small sketch which the architects liked. It represented, as Milles wrote, an angel "...holding a laurel branch in his hand and with his right hand he talks to the Lord about the dead soldiers."

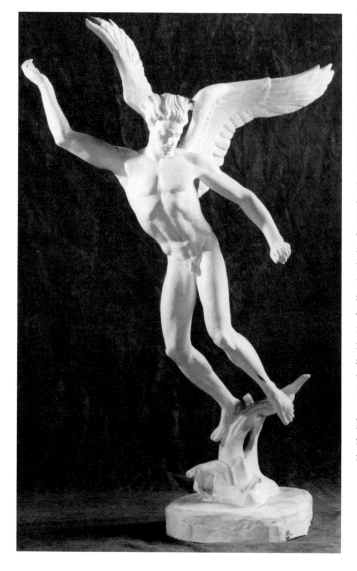

Milles also suggested that the figure be mounted on a tall black column. With these as his guidelines, Hord began to prepare a clay sketch for their approval. Hord wanted to produce a figure without wings, but his model was rejected. The Historical Society's plaster sketch was the third and final design. After acceptance by the Commission, Hord prepared a detailed scale model which was shipped to Florence, Italy, for enlargement. Hord followed in May of 1957 and, using the old studio of 19th century sculptor Giovanni Dupre, spent the next ten months in Italy completing the full-size clay model. One day a monk stopped by the studio and commented that an angel of peace should have an olive branch, not laurel, so this was changed before the Commission approved the large clay model in December. The final plaster was completed in Pietra Santa and approved in February of 1958.

The twelve foot tall bronze was cast in Milan after Hord had returned to the United States. Placed upon an eighteen foot tall granite shaft, it was dedicated on July 9, 1960. Hord never saw the finished bronze.

Works in collection: 2 bronzes, 1 wood, 1 stone,
8 plasters, 37 drawings, 1 watercolor,
extensive archival material

James Tank Porter

born: Tientsin, China, October 17, 1883
died: La Mesa, California, March 13, 1962

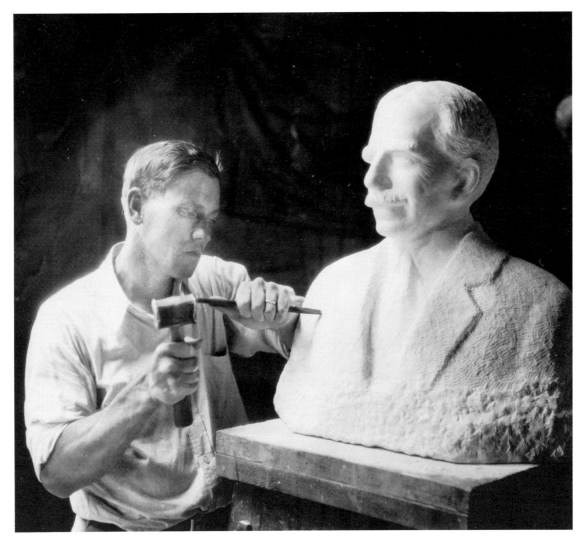

Porter's parents were medical missionaries who fled China at the time of the Boxer Rebellion. He received his education at Beloit College Academy in Wisconsin. In 1910, Porter entered Pomona College where his interest in art began to develop. After being graduated in 1914, Porter enrolled at the Art Students' League in New York. He also attended the Beaux Arts Institute where he placed second in the Prix de Rome competition in 1916. Porter worked briefly with Gutzon Borglum, and in 1918 became the first sculptor chosen to be among the group of students at the Louis C. Tiffany Foundation. In 1926, Porter attended the Santa Barbara School of the Arts where he studied bronze casting. He later started a foundry near his home in La Mesa so that he could cast his own work and that of other local artists. His bronze figure for the Ellen B. Scripps Testimonial in La Jolla dedicated in 1926 was the first free-standing public sculpture in San Diego. Porter became the first president of Contemporary Artists of San Diego when the group was formed in 1929. During the Depression years, he turned away from sculpture and began to use his knowledge of bronze casting to produce sprinkler heads.

32. Lot's Wife
(1929)
bronze,
23 1/2" high
signed on base
next to right foot
Gift of the
artist's daughter,
Anne Porter Hall
(1987.51.2)

33. Beatrice de Lack Krombach (1931)
bronze, 13" high
unsigned
Gift of the artist's daughter
Anne Porter Hall
(1987.51.1)

Beatrice Krombach (1879-1931) arrived in San Diego at the time of the 1915 exposition to become a significant local art personality. She wrote the "Art & Artists" column for the *San Diego Sun* and also a food column under the pen name "Leslie Ray." In the fall of 1923, she opened the Little Gallery where she held exhibitions of the work of many prominent artists including Lockwood de Forest, Maynard Dixon, Stanton MacDonald-Wright and local artists Maurice Braun, Charles Reiffel and Alfred Mitchell among others. Besides artists, a literary "salon" gathered at the gallery to read Proust and discuss the changing exhibits. After her death, Peyton Boswell took over the Little Gallery and it was here that he originated the magazine *Art Digest*.

Porter is known primarily as a portrait sculptor and his head of Miss Krombach, with its vivid expression, is one of his most compelling. He was not yet finished with the head when the sitter died so it had to be completed from memory. It was first shown at the Exhibition of Southern California Art in 1932. He also exhibited the head in Philadelphia and Chicago.

Judeo-Christian mythology includes the Old Testament story of Lot, a resident of Sodom, who sheltered and protected two strangers that turned out to be angels. In gratitude, the angels told Lot that they had been sent by the Lord to destroy the evil cities of Sodom and Gomorrah and that he should take his family and leave without looking back. Lot's family fled as the Lord destroyed the cities with fire and brimstone. Regretting the things she left behind, Lot's wife looked back and was turned into a pillar of salt.

Porter's figure is extremely stylized and shows the influence of Egyptian design. The discovery of Tutankhamen's tomb in 1922 caused a major revival of interest in the art of ancient Egypt during the Art Deco period. The tomb was not completely excavated until 1928, and the press kept the public aware of each new treasure that emerged. Typical of Egyptian design is the frontal view of the torso with the legs, arms and head in profile, which here creates a nearly two-dimensional effect. Porter first exhibited the bronze at the Exhibition of Southern California Art in 1929 and also exhibited it with the Contemporary Artists of San Diego at the Fine Arts Gallery in February of 1930.

Works in
collection:
2 bronzes,
1 terra cotta,
6 plasters

Charles Reiffel

born: Indianapolis, Indiana, April 9, 1862
died: San Diego, California, March 14, 1942

Reiffel's early years were spent in a clothing store with little indication of his future career in art. His artistic interests began to develop when he found work in a lithographer's shop, first in Cincinnati and later in New York. In the 1890s, he spent nearly six years traveling in North Africa and Europe where he studied art at the Munich Academy under Carl Marr. Upon his return, Reiffel settled in Buffalo and soon began to exhibit and win awards. In 1912, he purchased a home at Silvermine, Connecticut, and later helped found the Silvermine Artists' Guild becoming its first president in 1923. Planning a one-year visit to Santa Fe, New Mexico, in 1925, a storm forced him to re-route to San Diego where he settled for the rest of his life. In 1929, he became one of the original members of Contemporary Artists of San Diego. Reiffel had a remarkable exhibition and award record and achieved recognition as one of San Diego's most distinguished painters. He belonged to important art organizations and exhibited all over the country. During the Depression years, he painted several murals for local schools as well as the new civic center. He became known as "dean" of San Diego painters after the death of Maurice Braun in 1941.

34. San Diego Harbor (1937)
oil on canvas, 11' 2" x 10'10"
signed and dated lower right
On deposit from the General Services Administration, Washington, D. C. (1983-L-1.5)
(illustrated on front cover)

During the 1930s, Reiffel produced several murals and numerous easel paintings for the various art projects of the W.P.A. His first murals were a pair of canvas panels 20' x 14' for the Russ Auditorium at San Diego High School completed in 1936. These depicted backcountry and waterfront images of San Diego. The painting included here was one of a pair done for Memorial Junior High School in 1937. These murals were also interpretations of San Diego's waterfront and backcountry. The lower left corner of this panel is

inscribed "CITY SCHOOLS / CURRICULUM PROJECT / W.P.A. / MAY 27, 1937." A number of local artists including Belle Baranceanu and Hilda Priebisius also worked for the Curriculum Project.

The Memorial Junior High murals were treated as enormous easel paintings and are much more successful than the Russ murals. Reiffel created designs of abstracted patterns and shapes, boldly painted and brightly colored. These murals may have been painted in situ as the bolts holding them to the wall went through the front of the paintings and were painted over by the artist. In the mid 1970s, many local school buildings were demolished because they no longer met seismic safety requirements. A number of important W.P.A. murals were lost in the process. Reiffel's four murals were painted on stretched canvas and therefore could be removed and placed in City Schools storage. In 1983, these were

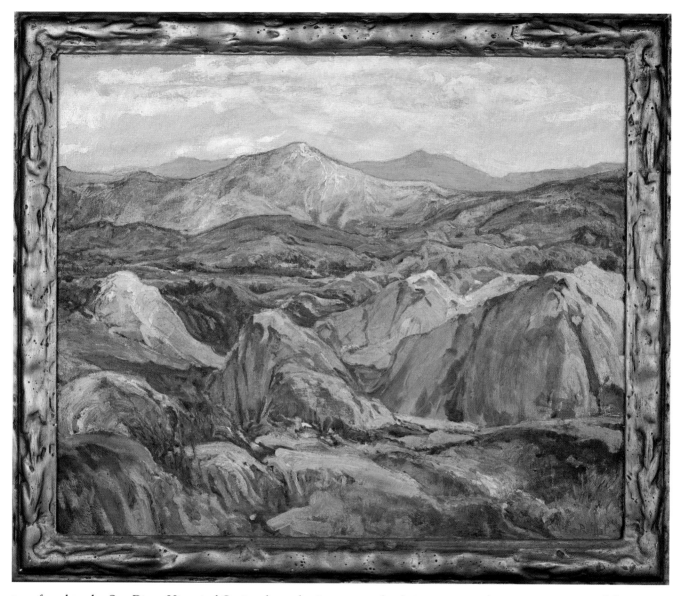

transferred to the San Diego Historical Society by authorization of the General Services Administration in Washington, D.C.. In November of 1985, the two Memorial Junior High murals were installed in the lobby of the Casa de Balboa, headquarters of the Historical Society in Balboa Park.

35. Mountains (late 1920s)
oil on canvas, 28" x 34"
signed lower right
Bequest of Helen Marston Beardsley (1982.47.1)

Mountains is an excellent example of Reiffel's depictions of the terrain around San Diego. It shows the underlying use of blue so typical of this artist's work. The brushstrokes seem to snake their way across the canvas creating undulating patterns that convey a feeling of movement. Parts of the painting have been painted using a heavy impasto and other areas are done in thin, transparent washes. Although obviously extensively worked, Reiffel was able to maintain a feeling of spontaneity. Everett Jackson, who sometimes painted with the artist, recalled how impressed he was by the confidence Reiffel projected while painting. The frame was designed and made by Alfred Mitchell who made many frames for Reiffel and other local artists (see also catalogue number 38).

Works in collection:
3 oils, 4 murals (on extended loan), 1 drawing

Otto Henry Schneider

born: Muscatine, Iowa, August 8, 1865
died: San Diego, California, January 23, 1950

Painter and printmaker Otto H. Schneider (not to be confused with Chicago artist Otto J. Schneider) studied at the Art Institute of Chicago under John Vanderpoel and Oliver Dennett Grover in 1890. He later took instruction at the Art Students' League in Buffalo, New York, where he specialized in drawing under Lucius Walcott Hitchcock. It was probably here that he met his wife Isabel, an artist also studying with Hitchcock. In 1900, he studied at the Art Students' League in New York under John H. Twatchman, George de Forest Brush and Henry Siddons Mowbray. Returning to Buffalo, Schneider supported himself painting portraits of notable people of that city. In 1910, the Schneiders traveled to Paris where Otto received criticism at the Academy Julian. He had the honor of having one of his landscape paintings hung at the Paris Salon of 1911. Before returning to the United States, he visited art centers in England, Holland, France and Italy. Other travels included the West Indies, Canada and much of the United States. From 1921 to 1923, he was instructor of painting at the Buffalo Academy of Fine Arts. After moving to San Diego about 1924, he became an instructor at the San Diego Academy of Fine Arts. In 1929, he helped establish Contemporary Artists of San Diego. A highly respected member of San Diego's art community, Schneider became one of the most influential local art teachers.

36. The Sheriff (ca. 1934)
oil on canvas, 13" x 16"
signed lower left
Gift of Frank B. Wisner, M.D.
(1980.48.2)

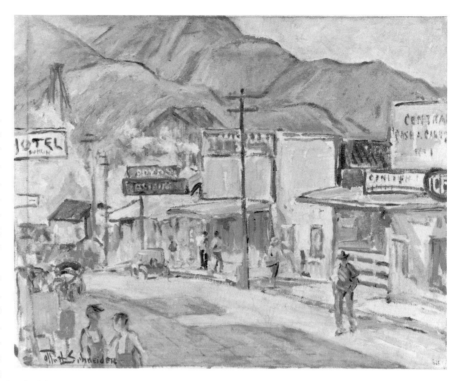

Schneider painted this sketch in Oatman, Arizona, a town along the western edge of the state about ninety miles south of Hoover Dam. He traveled to the construction site of the dam (then called Boulder Dam) in 1934 and produced a series of large canvases showing the enormous structure being built. These paintings are now the property of the City of San Diego.

The Sheriff is painted in the same dry technique used in the Boulder Dam pictures and probably dates from the same period. Both Otto Schneider and his wife, Isabel, exhibited paintings with Arizona subjects in the mid 1930s and may have made several trips to the state. Oatman, as painted by Schneider, looks like any other small western town of the period with one main street, rustic store fronts and vintage automobiles. The donor was Isabel Schneider's doctor who obtained this painting from her after the artist's death.

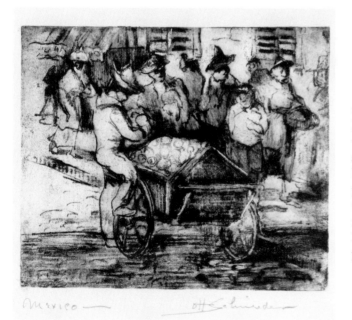

37. Mexico (late 1930s)
softground etching, 5 1/2" x 6 1/2" (image)
signed lower right margin
Gift of Ivan and Evelyn Messenger (1979.23.3)

San Diego's proximity to Mexico has provided a convenient source of subject matter for many local artists (see catalogue numbers 28, 30, 58, and 64). Schneider here shows a vendor with his cart on a crowded street. He has used the softground etching technique which produces soft, rich blacks and half-tones. In several areas he has burnished the plate to bring out details such as in the hats of the figures and the edges of the cart. Schneider exhibited softground etchings at the San Diego Art Guild in 1936 and 1939. Although less well-known as a print maker, his etchings exhibit a painterly quality similar to that found in his other work.

Works in collection:
1 oil, 1 watercolor, 1 etching

Leon Durand Bonnet

born: Philadelphia, Pennsylvania, September 12, 1868
died: San Diego, California, June 22, 1936

Bonnet came from a long line of artists and received his first instruction in art from his father. Originally educated for ministry in the Episcopal Church, he attended Bard College at Columbia University. Deciding on a career in art, he enrolled at the Pennsylvania Academy of Fine Arts where he studied with Eliot Clark and Edward Potthast. Bonnet maintained a studio in Tuxedo, New York, as well as a summer studio in Ogunquit, Maine. In 1915, he was elected to membership in both the National Arts Club and Salmagundi Club in New York. Bonnet's health forced him to find a more temperate climate during the cold winter months. Maintaining his two east coast residences, he wintered and painted in Bermuda in 1924, Carmel in 1925, Ojai in 1926, Coronado in 1927, and finally purchased a home in Bonita in 1928. That same year he and his wife established the Bonita School, a private school for boys, which lasted until the war. Elected to membership in Allied Artists of America in 1928, the following year he became a member of Contemporary Artists of San Diego and in 1930 a member of the Ogunquit Art Association . Beatrice Krombach had an exhibition of his work at her Little Gallery in February of 1928, soon after his arrival, and his first solo exhibition at the San Diego Fine Arts Gallery was held in June of 1929. This same gallery held a memorial exhibition in November and December of 1936.

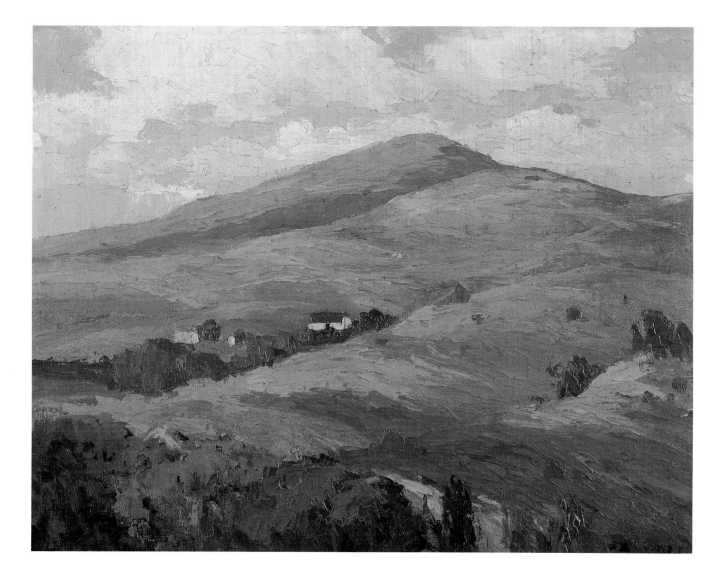

38. San Miguel (early 1930s)
oil on canvasboard, 12" x 16"
signed lower right
Gift of the artist's son, E. Scofield Bonnet (1990.30)

Mount San Miguel is one of San Diego's most frequently painted natural landmarks. Bonnet here depicts the southern slope of the mountain with his typical lush colors. Originally painted with a brush, the artist completely reworked the composition using a palette knife, partially obscuring his signature. The frame was designed and made by Alfred Mitchell who made many frames for Bonnet and other local artists (see catalogue number 35). *San Miguel* was included in the artist's memorial exhibition at the Fine Arts Gallery in 1936.

Works in collection:
2 oils

Elliot Bouton Torrey

born: East Hardwick, Vermont, January 7, 1867
died: San Diego, California, March 10, 1949

Torrey was related to the botanist Dr. John Torrey, discoverer of the rare Torrey Pine trees. Elliot Torrey received his education at Bowdoin College where he completed his M.A. degree in 1890. He spent several years abroad studying in Paris and Florence before returning to establish a studio in Boston. After two additional trips to Europe, Torrey established a studio in New York City in 1911. Coming to California in 1923, he settled in Pasadena for several years before moving to San Diego in 1927. In 1929, he became one of the original members of Contemporary Artists of San Diego. During the Depression years, Torrey became involved with the government art programs, initially assisting Reginald Poland with directing the local W.P.A. Art Project. With memberships in the Salmagundi Club, Society of American Artists, San Diego Art Guild and Laguna Beach Art Association, Torrey exhibited frequently and often served as a juror. He inherited the title "Dean of San Diego Painters" after the death of Charles Reiffel in 1942. His work is represented in important museums across the country.

39. Head of a Child (late 1920s?)
oil on canvasboard, 15" x 12"
signed upper right
Gift of the Estate of Leda Klauber (1981.54.1)

Torrey, a life-long bachelor, had a fondness for painting children and is believed to have used his nieces as models. This sensitively painted head shows the artist's rapid method of capturing his sitter's appearance, an essential ability when painting children. He has contrasted the softness of the child's features with the rather wildly painted background and dress which are done primarily with a palette knife.

Works in collection:
3 oils

Hope Mercereau Bryson

born: St. Louis, Missouri, January 4, 1887
died: New York, New York, March 23, 1944

Bryson began her study of art at the National Academy of Design in New York in 1918, followed by a year at the Corcoran School in Washington, D.C., under Edmond C. Tarbell. Later, in Paris, she studied painting from the nude under Charles Guerin, portrait work under Morrisset, and also studied at the Academy of the Grande Chaumiere under Claudio Castelucho. In 1923 and 1924, she took independent study from Edwin Scott. She moved to San Diego with her husband, Lyman Bryson, a writer and educator, in 1926 and the couple settled in Mission Hills. A member of the California Watercolor Society, she often exhibited with that group in Los Angeles. She was also a member of the Laguna Beach Art Association, San Diego Art Guild and Berkeley Art Guild. Exhibiting frequently in southern California in the late 1920s and early 1930s, she remained in San Diego until at least 1936. She spent the final years of her life in New York.

40. Dutch Importer (1931)
oil on canvas, 40" x 32"
signed lower right
Gift of Mrs. Thomas McMullen (1973.20.1)

Born in Holland, Pieter Smoor arrived in San Diego about 1924 and taught art at the Francis Parker School from 1924 until 1930. He established a shop downtown where he sold Dutch and other imported art goods and this became San Diego's first fine gift shop. Bryson painted her portrait of Smoor in his second shop at Fourth and Laurel streets which he operated from 1929 to 1937. This location included an art gallery where many local artists showed their work. Smoor served as president of the Fine Arts Society in 1937 and 1938 and later retired to paint in San Miguel de Allende, Mexico. He died in Sacramento in 1980.

The Brysons were good friends of Smoor and his wife. In 1979, Smoor wrote "I had a shop of art goods in San Diego during the thirties. Being the period of the famous 'depression,' there were hours of waiting for a customer. Hope Bryson brought her canvas and paint materials and decided to paint my portrait — we spent pleasant afternoons. I stand in front of my shelves of Leerdam (Holland) crystal — hold one such piece in my hand." Bryson has captured the sitter's features and effect of daylight streaming through the shop windows using broad planes of color. *Dutch Importer* was accepted for the Painters & Sculptors of Southern California exhibition at the Los Angeles County Museum of Art in 1932.

Works in collection:
1 oil, 2 watercolors

Katharine Morrison Kahle McClinton

born: San Francisco, California, January 23, 1899
(currently residing in New York City)

McClinton received her first training in art from her mother, San Francisco painter Leila Perry Morrison. Attending Stanford University, she received her B.A. degree in 1921 and an M.A. from Columbia University the following year. After her marriage to Richard Kahle, a lawyer, in 1923, the couple lived in San Diego where she taught design and decoration at the San Diego Academy of Fine Arts for one semester. Visiting Paris in 1925, she attended the Exposition des Arts Decoratifs. She returned three years later to view the Salon des Artistes Decorateurs. These two experiences led to her book *Modern French Decoration* published in 1930, which featured the style now known as Art Deco. For three years, she wrote the art column for the *San Diego Sun*, and also contributed articles to other publications including *House Beautiful*, *International Studio*, and *Connoisseur*. As a painter, she had works accepted for exhibitions in San Diego, Los Angeles, Pasadena, Santa Barbara and San Francisco. Locally, she was a member of the San Diego Art Guild and also exhibited with the San Diego Moderns. In 1935, she married Harold Leigh McClinton, an official of the Ford Company who was in charge of the Ford Building during the 1935 exposition. They resided in New York, and since that time, McClinton has written dozens of articles and over thirty books on antiques and interior decoration.

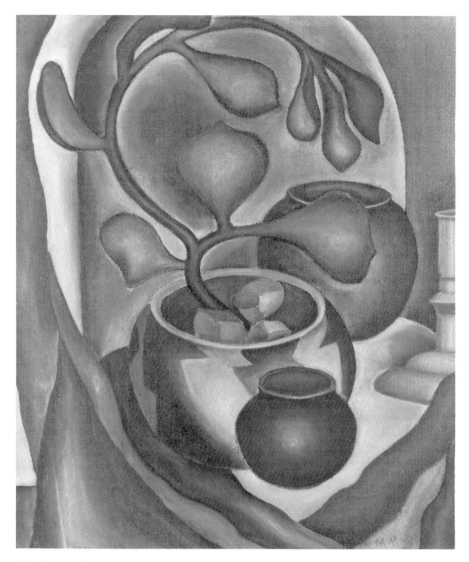

41. Western Still-Life (ca. 1932)
oil on masonite, 22" x 19"
signed in pencil lower left
Gift of the artist (1990.83)

The artist's interest in modern design is strongly evident in this work. She creates a tight composition of complimentary shapes and patterns. The arch of the background is echoed in the arch formed by the branches of the jade plant, while the clean modest forms of the Indian pottery are contrasted with the turned elegance of the candlestick. A slightly cubistic perspective and ambiguous foreground provide a note of disorder that is thoughtfully balanced by the simplicity of the objects.

Although better known as an author and journalist than as an artist, McClinton exhibited a number of paintings in the early 1930s. *Western Still-Life* was first shown in 1932 at both the San Diego Art Guild and the important 54th Annual Exhibition of the San Francisco Art Association. It was also accepted for the California State Fair in Sacramento and the 6th Annual State Wide Exhibition in Oakland. After moving to New York, she exhibited it at the Bronxville Women's Club.

Works in collection:
1 oil

Esther Stevens Barney

born: Indianapolis, Indiana, January 6, 1885
died: San Diego, California, January 18, 1969

After her graduation at Stanford University, Stevens attended the Art Association in San Francisco for a year. She studied at the Art Students' League for a year and a half before going abroad where she was among a group of students who painted with Robert Henri in Spain. Upon her return, she continued her studies at the Beaux Arts Institute in New York where she won first medal for mural painting. Returning to the west coast, she lived in the San Francisco Bay area. After her marriage to Walter R. Barney, the couple moved to San Diego in 1921. They lived on a homesteaded ranch in Ramona, which became a popular destination for many local artists. In the early 1930s the couple separated and Esther divided her time between San Diego and Ramona. During the Depression she went on the government payroll and produced some work for the California-Pacific International Exposition for which she received the bronze medal. After the fair she produced a line of hand block-printed textiles. During the war years, she moved back to the Ramona ranch. Her country home and studio were later destroyed by a fire in which the work of a lifetime went up in flames. She retired to La Jolla about 1959.

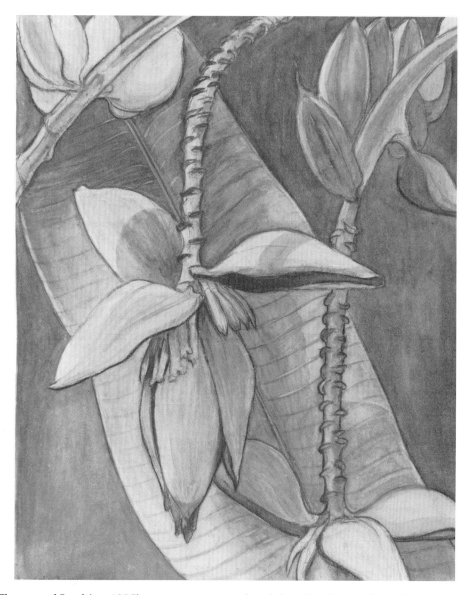

42. Banana Flower and Leaf (ca. 1935)
watercolor and charcoal, 16" x 13"
signed lower left
Gift of Ivan and Evelyn Messenger
(1979.29.8)

Barney had a special interest in painting plant forms and was greatly influenced by the unusual plants native to the arid southwest. Here she chose something more tropical for her subject and employed the banana plant to create a composition in which the broad leaf shape is transected by the flower and fruit forms. By showing only a detail section of the plant, the individual parts become almost abstract design elements. Although now somewhat faded, the blossoms original-

ly exhibited brighter pinks and purples.

For the California-Pacific International Exposition in 1935-36, Barney produced an eight by five foot mural *Gateway to the Desert* in which she depicted cactus and succulent plants. Also for the fair, she designed hangings for the Flamingo Room and a gold screen for the Sala de Oro in the House of Hospitality. At the fair's official art exhibition, she exhibited a hanging depicting a banana plant and also a watercolor titled *Banana Flower and Leaf* which may be the piece shown here. She received a bronze medal for her various efforts at the exposition.

Works in collection:
1 watercolor

Anni von Westrum Baldaugh

born: Holland, August 10, 1881
died: El Cajon, California, August 8, 1953

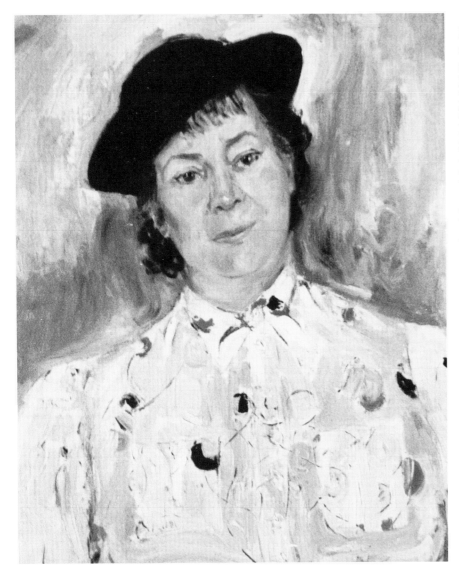

Born into an affluent family, Baldaugh spent much of her youth in the Dutch East Indies where her father represented the Dutch government. Returning to Europe, she studied art in Haarlem, Vienna, and Munich, and became a member of the Beaux Arts Institute in Paris. Moving to the United States in the 1910's, possibly to escape the war in Europe, she was listed in San Francisco in 1915 and New York in 1921. She settled in Los Angeles in the early 1920's and became an active member of the Southern California art scene winning numerous awards for miniatures, watercolors and oils. About 1929, Baldaugh relocated to San Diego. Her family had suffered greatly in the first World War, and she spent the Depression years in extreme poverty. She set up a studio in Balboa Park and taught art classes to supplement her meager income. Baldaugh continued to exhibit throughout California until the late 1940's.

From a painting by
Georgia Crittenden Bemis

43. Murial (ca. 1926)
oil on board, 21" x 23"
signed lower left
Anonymous gift (1984.72.6)

Baldaugh must have thought that *Murial* was one of her finest paintings because she exhibited it more often than any other known work. It is first listed as having been shown at the Modern Art Workers exhibition at the Los Angeles County Museum of Art in 1926, a few years before Baldaugh moved to San Diego. In 1928, it was accepted for the

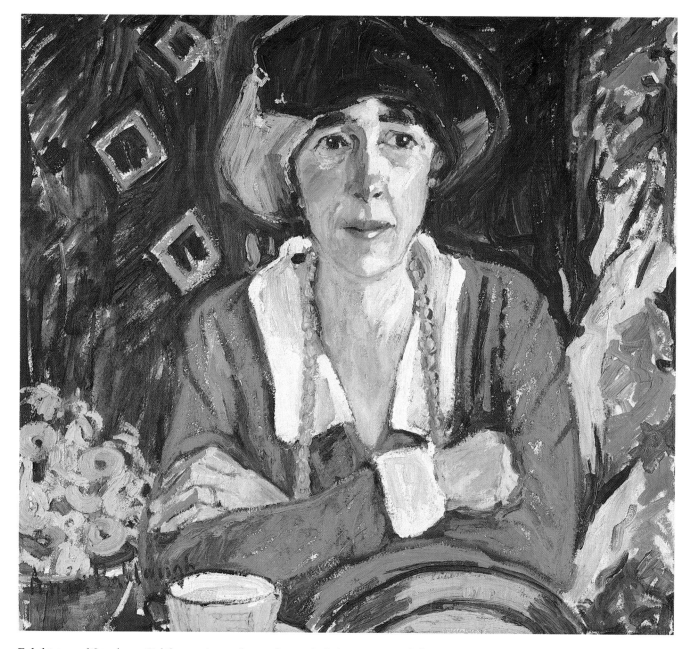

Exhibition of Southern California Art and was also included in the California-Pacific International Exposition in San Diego in 1935. It was again accepted for the Exhibition of Southern California Art in 1939 and shown at the Escondido Annual Art Exhibition in 1941. The Denver Art Museum exhibited it in 1945, the California Palace of the Legion of Honor in San Francisco in 1946, and the California State Fair in Sacramento in 1947. Inscriptions and labels on the back indicate that it was also shown in Santa Barbara, Chicago, and New York, and won several cash prizes. This remarkable record indicates that the painting continued to impress exhibition jurors for over twenty years.

Many of Baldaugh's portraits have first-name titles such as *Rita*, *Donna*, *Margarita*, and *Dianne*, making identity of the sitters difficult. *Murial's* vivid colors, bold treatment and casual pose create a spontaneity that gives the portrait a vibrantly life-like quality. The painting was owned for a time by the artist's good friend, the painter Hazel Brayton Shoven.

Works in collection:
2 oils

Dorr Hodgson Bothwell

born: San Francisco, California, May 3, 1902
(currently residing in Mendocino and Joshua Tree, California)

Dorr Bothwell's parents knew Anna and Albert Valentien, and Dorr began her art studies under Anna Valentien in 1916 with Donal Hord as a classmate. In the early 1920s she studied at the California School of Fine Arts in San Francisco, University of Oregon in Eugene and the Rudolph School of Design in San Francisco. After receiving a modest inheritance, Dorr traveled to American Samoa in 1928. Remaining in Samoa for two years, she produced many works of art in a wide variety of media. Some of these were successfully shown at the Fine Arts Gallery in San Diego and the Beaux Gallery in San Francisco allowing her to spend a year in England, France and Germany. Returning to San Diego in 1931, Dorr became reinvolved with the San Diego art community and exhibited with the San Diego Moderns and San Diego Art Guild, winning the Leisser-Farnham prize in 1932. She married Donal Hord in 1932, but the marriage proved unsuccessful and they separated in 1934. In 1933, she produced an egg tempera painting on a gilt gesso panel for the Public Works of Art Project. Moving north, she later produced several murals for the W.P.A. in Los Angeles and Riverside and another for a coffee company in San Francisco in 1939. Bothwell taught at the California School of Design in the early 1940s and in 1952 taught at the Parsons School of Design. She has traveled and studied widely in Europe, Africa and Southeast Asia and her work is represented in major museums all over the world.

44. Portrait of Eileen Jackson (1933)
black and brown chalk, 17" x 12"
signed and dated lower right
Gift of Everett and Eileen Jackson (1987.29.2)

Born in 1906, native San Diegan Eileen Dwyer married Everett Gee Jackson (see catalogue numbers 47 and 48) in 1926. Her career in journalism started while still a teenager when she began to cover stories for the *San Diego Sun*. In 1930, she moved to the *San Diego Union*, covering San Diego's social scene in her "Tete-a-Tete" column which ran for many years. From 1948 to 1952 she acted as society editor for the *San Diego Journal* before returning to the *Union* to write her "Straws in the Wind" column. Although she retired from the *Union* in 1976, she wrote a weekly column for the *San Diego Evening Tribune* from 1981 to 1990.

Because of her connection to both social and artistic circles, Eileen Jackson became an important link between the two. When Mrs. Claus Spreckels asked to meet sculptor Donal Hord, Eileen arranged the meeting at his tiny studio on Pascoe Street. When the shy sculptor offered the wealthy socialite coffee, she was amused and delighted when he opened the can of milk with one of his sculptor's chisels.

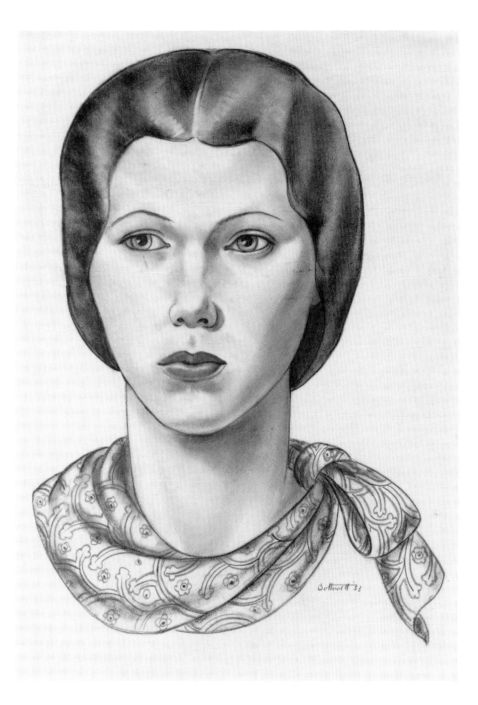

Bothwell, Hord and the Jacksons were close friends, and after their marriage in 1932, Bothwell and Hord spent the first night of their honeymoon at the Jackson's home. Bothwell drew this strongly linear portrait of Eileen in 1933. On October 29th of that year the first page of the "Club" section in the *San Diego Union* ran a series of Bothwell's drawings of ladies prominent in the Junior League. Although similar to the Eileen Jackson portrait, these are not nearly as refined. It is interesting to compare this portrait to one done of the same sitter several years later by Margot Rocle (see catalogue number 49) to see how differently the two artists interpreted her features.

Works in collection:
1 oil, 4 drawings

Belle Goldschlager Baranceanu

born: Chicago, Illinois, July 17, 1902
died: La Jolla, California, January 10, 1988

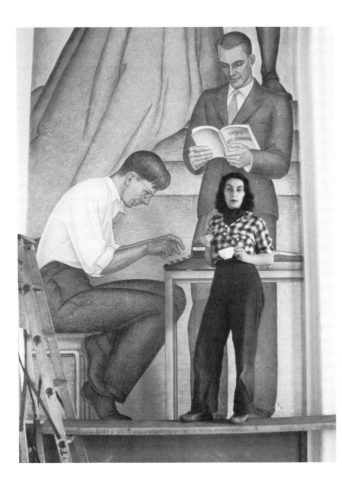

After being graduated from the Minneapolis School of Art in 1924, Baranceanu continued there as a post-graduate student under Anthony Angarola. In order to continue her studies with Angarola, Baranceanu followed him to the Art Institute of Chicago where she enrolled in 1925. She painted and exhibited in Los Angeles in 1927 and 1928 before return-ing to Chicago. Although she won a major award and had several exhibitions in Chicago, in the wake of the Depression she decided to move with her family to California. Settling in San Diego in 1933, Baranceanu soon became involved with the various federal art programs. She produced a number of murals as well as other government sponsored artwork includ-ing a large mural for the California-Pacific International Exposition where she received the silver medal. During the 1940s, she continued to do mural and portrait work for pri-vate clients, and began teaching at the San Diego School of Arts and Crafts and the Francis Parker School. In 1950 she was elected president of the San Diego Art Guild. Late in her career she began to experiment with abstractions based on lights reflecting off the San Diego Bay at night.

45. Milkweed (ca.1932)
oil on canvas, 28" x 26"
signed lower right
Gift of the artist (1983.46.5)

Milkweed is an excellent example of Baranceanu's care-fully designed compositions. Using a dark blue outline to delineate the simple shapes, she developed an arrangement of flat patterns in muted color harmonies. The strongly geo-metricised background is contrasted with the irregular out-lines of the blue cloth on the table and the feathery softness of the milkweed blossoms. A large building seen through an open window provides a sense of depth which is enhanced by the sharp, almost cubistic, angle of the table top. Baranceanu

felt that subject matter was "...important only in so far as it is recreated to stimulate the imagination to the awareness of beauty, since there is beauty in all things."

Baranceanu's San Diego debut appears to have been at the 8th Annual exhibition of the San Diego Art Guild in November of 1933. A jury consisting of Barse Miller, Lena Patterson and Merrell Gage accepted three of her paintings, more than any other artist. Reviewing the show for the *San Diego Union*, Reginald Poland preferred *Milkweed* to her

other works writing "...'Still-life' is perhaps a bit too chaotic in its cubistic (or is it synchromistic?) aspect. The landscape 'From Everett Hill' has solved a similar problem better than her still-life, and has a quiet mood and rich mellow tone. '*Milkweed*,' though painted according to a careful plan, appears spontaneous, a beautiful interpretation of objects and of rare good taste."

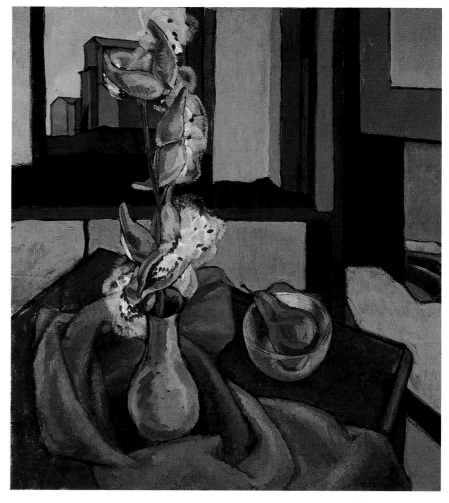

46. Drill Baboon (ca.1940)
linocut in five colors,
11 3/4" x 11" (image)
signed lower right
(number 10 of 50 impressions)
Gift of the artist (1983.46.23)

While employed for the W.P.A. Curriculum Project, Baranceanu produced a series of linoleum block prints to be used as covers for text books. Most of these depicted animals and demonstrate her remarkable sense of composition using bold shapes and clean lines. The printing blocks became the property of the W.P.A. so Baranceanu had to re-cut each of the designs to produce her own editions. She added several new works to the series including *Drill Baboon*. The only one of her animal prints to use more than one color, a separate block had to be cut for each. The Historical Society owns two copies of *Drill Baboon* which are printed in slightly different tones. Baranceanu's most complicated print, it received first prize in graphics at the San Diego Art Guild's annual exhibition in 1940.

Works in collection:
13 oils, 2 murals (on extended loan), 3 lithographs, 14 blockprints, 200+ drawings, sketches and mural cartoons, extensive archival material

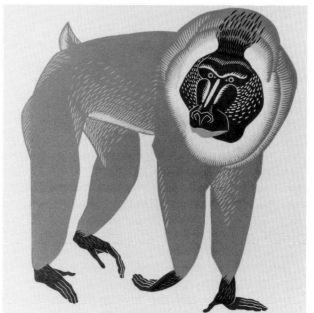

73

Everett Gee Jackson

born: Mexia, Texas, October 8, 1900
(currently residing in San Diego)

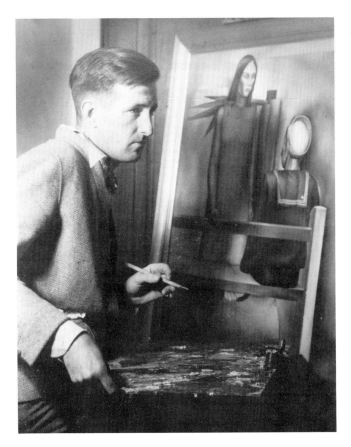

After initial studies in architecture at Texas A & M University, Jackson decided to pursue a career in art and enrolled at the Art Institute of Chicago. He stayed in San Diego for a few months in 1923 and briefly studied with Eugene De Vol and Otto H. Schneider at the San Diego Academy of Fine Arts. While in San Diego, he met his future wife, Eileen. Returning to Texas, Jackson was joined by Lowell Houser, a classmate from Chicago, and the two began the first of many painting trips into Mexico. After working in Guadalajara, Guanajuato and Chapala, they settled in Ajijic, becoming the first artists in that art colony. Jackson spent a year in Mexico with his bride before returning to San Diego in 1928. He was asked to join Contemporary Artists of San Diego the following year. Obtaining a teaching job at San Diego State College in 1930, he later became chairman of the art department. Active in local art circles, he served as president of the San Diego Art Guild in 1931, and later founded the Latin American Art Committee of the Fine Arts Society. In 1939, he had paintings accepted for both the San Francisco and New York World's Fairs. During the 1930s he began to work in lithography, and later achieved distinction as a book illustrator. In 1979, a major retrospective of his work was held in Mexico City. Two years later, President Ronald Reagan presented one of his paintings to Mexican President Jose Lopez Portillo.

47. Sea Duty (1939)
oil on canvas, 40" x 36"
signed and dated lower left
Gift of the artist's daughter, Mrs. Tom Williamson
(1990.25)

After living and painting in the picturesque villages of Mexico for several years, Jackson found little to compare with them in pictorial potential when he moved to San Diego. Even before World War II San Diego had a strong Navy presence and Jackson became interested in depicting the local sailors in uniform. A group of paintings from the 1930s including *Mail Orderlies, U.S.N.* (1933), *Sailor Beware*

(1934), and *Embarkation* (1937) as well as the lithograph *Sailor Take Care* (1934) are all based on a Navy theme.

Sea Duty is one of the last of Jackson's sailor pictures. In it, he sought to capture both the sadness of the sailor saying goodbye to his family and the general bleakness of the Depression era. The extremely limited palette, typical of Jackson's work at this period, adds to the painting's somber

effect. Using just the faintest hint of pink in the baby's bonnet and a pale yellow in the woman's dress, he has maintained a primarily neutral color scheme. A dull reddish area in the lower right corner of the canvas is the strongest color in the painting.

In addition to the color scheme, the painting's mood is enhanced by the ambiguous spacial relationships of the various elements of the composition. The viewer is intentionally blocked from relating to the figures. The sailor is seen from behind and his wife, who seems to float mysteriously, turns her head away. A baby peers over the father's shoulder, unaware of her parent's turmoil, adding a touch of poignancy to the scene.

Although the picture plane appears shallow, Jackson has created a feeling of depth by using a strong diagonal line for the dock and including two figures in a smaller scale in the background. These two figures, men out of work with heads bowed, add to the sense of loneliness, as do the two seagulls standing in a broad expanse of empty canvas on the left. Jackson has compressed the composition by having all of the lines and shapes stop short of the picture edge with the single exception of the tree. The entire painting conveys a feeling of strangeness that approaches surrealism.

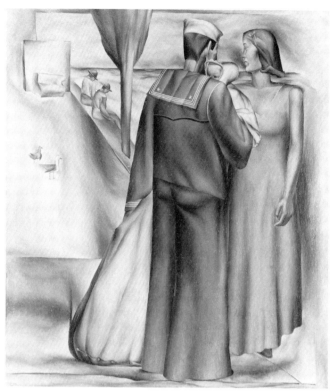

48. Portrait of Ivan Messenger (1933)
lithograph, 8" x 6 1/4" (image)
signed and dated lower right margin (number 19 of 25 impressions)
Gift of Ivan and Evelyn Messenger (1982.38.2)

Messenger and Jackson were good friends and often worked together. Jackson drew this image while Messenger was working on his own first lithograph in the basement of the Fine Arts Gallery. Since the image was drawn directly from life, reversal during the printing process gives the false impression that Messenger was left-handed. The composition is highly stylized, but even small details such as the initial "M" on the sitter's belt buckle have been carefully recorded. Jackson's lithographs demonstrate a strong graphic sense, with his emphasis on angular linearity, repeated patterns, and subtle tonalities. He later used these qualities for producing book illustrations which earned him an award from the Limited Editions Club in 1954.

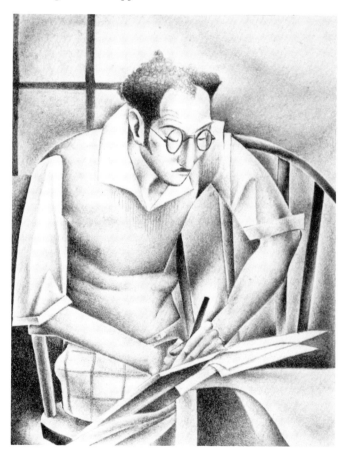

Works in collection:
1 oil, 2 lithographs,
1 zinc lithography plate with drawing

Margaret (Margot) King Rocle

born: Watkins Glen, New York, March 6, 1893
died: Ramona, California, November 9, 1981

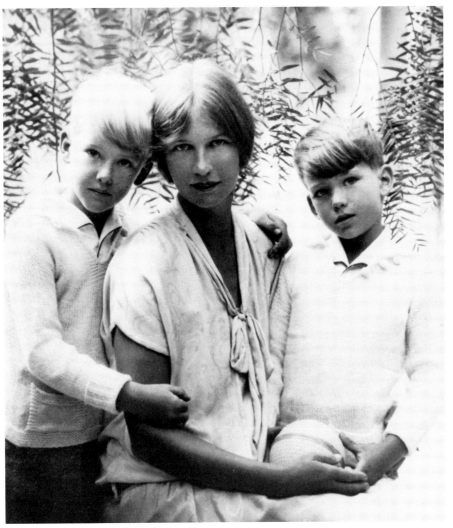

Margot Rocle with her two sons.

Margaret received her first instruction in art at the Pennsylvania Academy of Fine Arts and later in New York at the school of William Merritt Chase and at the Art Students' League. During World War I, she enlisted as a war nurse in France where she met Marius Rocle whom she married in 1918, shortly before the armistice was signed. After the war, the couple moved briefly to New York before returning to France, but the changes in Europe were such that the couple decided to return to the United States, settling in California about 1921. They purchased a lemon ranch in Chula Vista, which provided their livelihood allowing them to devote much of their time to art. Margot seriously turned her attention to art about 1925 and maintained a remarkable exhibition record until the early 1940s. She exhibited across the country and won many awards. Margot was a member of the Society of Independent Artists, Salons of America, San Francisco Society of Women Painters, Laguna Beach Art Association, San Diego Art Guild and San Diego Moderns.

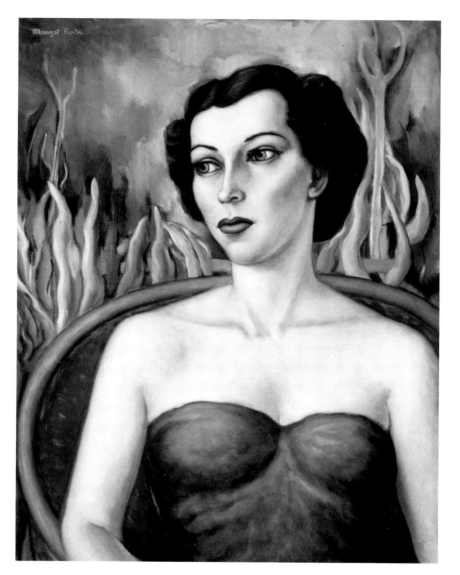

49. Eileen (ca. 1939)
oil on canvas, 30" x 24"
signed upper left
Gift of Everett and Eileen Jackson (1987.29.1)

Margot Rocle chose a decidedly different interpretation than did Dorr Bothwell in her portrait of the same sitter (see catalogue number 44). *Eileen* was exhibited in a show of portraits at the Fine Arts Gallery in September of 1939 where Hazel Braun thought it captured the sitter's "...serious mood as Margot Rocle saw her." Discussing the same show, Julia G. Andrews wrote "In an exhibition of paintings which presents as wide a range of time and style as is the case here, there should be satisfaction for many tastes, whether the preference be for realism...or for fantasy as we see it in Margot Rocle's haunting portrait of Mrs. Everett Jackson, who seems to have stepped out of the story world of some medieval Book of Hours."

Eileen was accepted for exhibition at the San Francisco Art Association in 1940. It was shown again at the Fine Arts Gallery of San Diego in a solo exhibition of Rocle's work in November of 1941 where Reginald Poland called it a "fine interpretation." Eileen Jackson later used it at the head of her column in the *San Diego Union*.

Works in collection:
1 oil, 1 lithograph

Marius Romain Rocle

born: Brussels, Belgium, June 6, 1897
died: Ramona, California, November 16, 1967

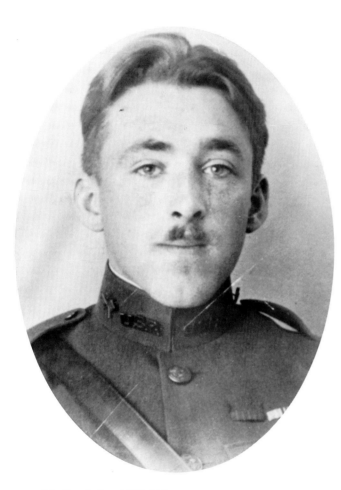

Marius spent much of his youth in Paris where his father was once editor of *Figaro*. At the onset of war, he enlisted for military service from New York in 1914. After two years in the infantry, where he received the Croix de Guerre, he transferred to aviation and joined the Lafayette Flying Corps. While quartered at a hotel in Paris, he met his future wife Margaret King who was staying in the same hotel. After moving to California, Marius took his first instruction in art from his wife. Progressing rapidly, he was exhibiting locally by 1928 and won a first prize at the San Diego Art Guild in 1931. He maintained memberships in the San Diego Art Guild, Laguna Beach Art Association, Society of Independent Artists, Salons of America, and exhibited with the San Diego Moderns in the early 1930s. He had pieces accepted for the Century of Progress Exposition in Chicago in 1934, the California-Pacific International Exposition in 1935, and the Golden Gate International Exposition in San Francisco in 1940. After the premature death of two sons and with young twin daughters to raise, the Rocles began to drop out of the local art scene in the 1940s. Moving to Ramona in 1955, they continued their second great interest, raising saddlebred and Arabian horses.

50. Roofs (ca. 1930-31)
oil on canvas, 38" x 30"
signed lower left
Gift of the artist's daughter, Judith Rocle (1987.23.1)

In February of 1931, the Rocle's returned from a year's trip abroad during which they visited Paris, Switzerland, the Riviera, Italy and the Island of Corsica. *Roofs* must have been painted on or immediately after that trip and it was accepted for the Exhibition of Southern California Art in the Spring of 1931. This may also be the painting mentioned in a San Francisco newspaper as part of Rocle's exhibition at the Galerie Beaux Arts in January of 1933: "There is a large canvas 'Daughine,' orange-red colored housetops on a hillside, that is very entrancing." "Daughine" is no doubt a misprint of

Dauphine, a mountainous province in the southeast corner of France.

A wide variety of influences turn up in Marius Rocle's work, from Cezanne and Vlamink to Grant Wood and the Surrealists. *Roofs* shows a particular debt to Vlamink, an artist that the Rocles knew and whose work was represented in their personal collection. Ada Hanafin in the January 1933 *San Francisco Examiner* wrote "There is a masculinity about the paintings of Marius Rocle that I like. He paints in the spirit of today. He is modern but does not go to extremes."

Works in collection:
1 oil, 2 lithographs

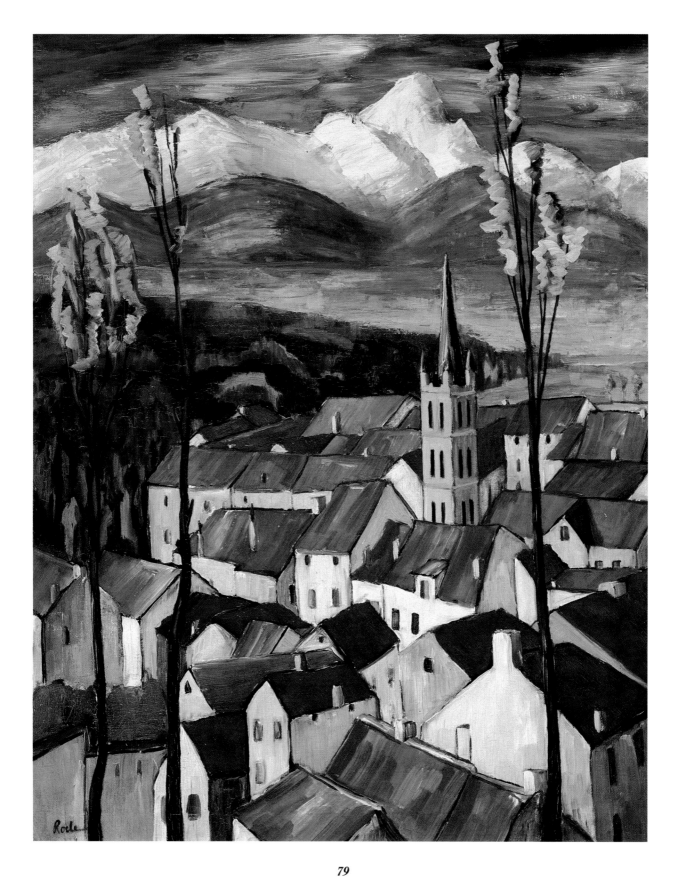

ROCLE

Ivan Messenger

born: Omaha, Nebraska, March 24, 1895
died: San Diego, California, September 6, 1983

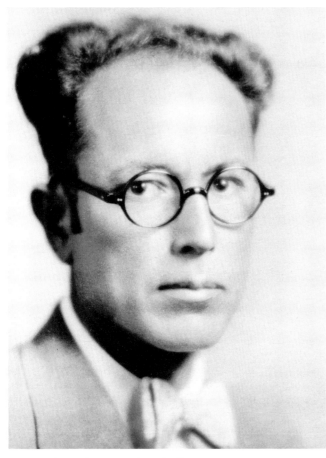

Messenger received his early education in Colorado and Los Angeles. In 1917, his family moved to San Diego County and worked a farm in the Lyons Valley east of San Diego. He later attended Stanford University where he received an M.A. degree in romance languages in 1921. He taught language at Stanford and the University of Texas for a time before returning to San Diego about 1925. Without formal training in art, Messenger began to work in various media and had his first solo exhibition in San Diego in 1926. He worked in Mexico in 1922 and 1932, and from 1936 to 1937 he painted in South America. Becoming a member of the informal group called the San Diego Moderns, he exhibited with them in the early 1930s. He frequently exhibited throughout California particularly during the 1930s and 1940s. His work was included in the official exhibitions of the California-Pacific International Exposition in San Diego in 1935 and the Golden Gate International Exposition in San Francisco in 1940. Besides his work as a painter, Messenger was also a highly skilled and prolific printmaker.

51. Serra Museum (ca.1935)
oil on canvas, 25" x 22 1/2"
signed bottom center
Society Purchase and gift of the artist (1976.59.1)

George W. Marston constructed the Junipero Serra Museum as a memorial to Father Serra (see catalogue number 53) and home for the San Diego Historical Society which he helped found in 1928. It was constructed adjacent to the site of the San Diego presidio, the first Spanish settlement in Alta California. Designed by William Templeton Johnson, the museum is an outstanding example of Mission Revival architecture. Its dedication took place on July 16, 1929, the 160th anniversary of the founding of San Diego by Junipero Serra.

Messenger had close ties to the Historical Society and

Serra Museum. His father-in-law, Senator Leroy Wright, was founding vice-president of the organization and succeeded Marston as president in 1930. Senator Wright continued in that position until his death in 1944. Messenger had a deep interest in history and made numerous donations of artwork and other material to the Historical Society.

In his painting *Serra Museum*, Messenger created a nearly monochromatic composition. The paint has been applied in wide, boldly curving brushstrokes which produce a feeling of movement. He has concentrated on the tower end of the building, but compressed its height, giving the structure a more massive appearance. A single figure can be seen ascending the exterior staircase on the right. This painting was accepted for exhibition at the Golden Gate International Exposition in San Francisco in 1940.

52. San Diego Plaza (ca.1946)
lithograph, 10 1/4" x 14" (image)
signed lower right,
printed by Paul Roeher
Gift of Ivan and Evelyn Messenger
(1980.3.4)

San Diego Plaza is an excellent
example of Messenger's rather whimsical
approach to depicting daily life. He here
records the typical hustle and bustle of
Horton Plaza (see catalogue number 25)
in the mid 1940s. A billboard clock
marks 3:00 PM as commuters rush to
catch their streetcar, weary shoppers rest
on park benches, dogs are walked,
pigeons are fed, and sailors stare at pretty
girls. Messenger's view point was from
the terrace of the U. S. Grant Hotel and
he has intentionally removed the power
lines and most of the palm trees in order
to keep his composition open. In the
background are seen such San Diego
landmarks as the office of "Painless
Parker" dentist and the Hotel Barbara
Worth. The Cabrillo Theater advertises
an Abbott & Costello movie while the
Plaza next door features Maria Montez.
Messenger has admirably captured the
post-war ambience of the heart of San
Diego with cartoon-like directness and
simplicity. *San Diego Plaza* was accepted
for the official art exhibition of the
California State Fair in 1947 and this
particular example of the print was
included in the artist's one-man show at
the Palm Springs Desert Museum in
1979.

Works in collection:
16 oils, 1 watercolor, 8 drawings,
15 etchings (2 unique impressions)
4 lithographs,
1 litho stone with
drawings on both sides

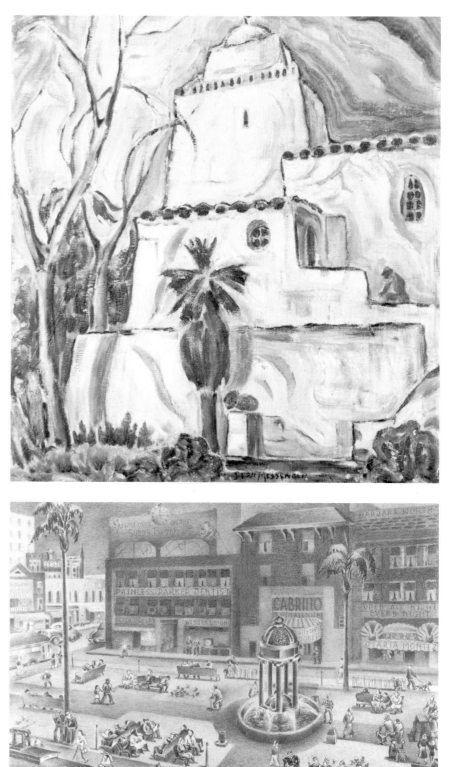

Alfredo Ramos Martinez

born: Monterrey, Mexico, November 12, 1872
died: Los Angeles, California, November 8, 1946

By the age of ten, Martinez had received a scholarship to the Academy of Fine Arts in Mexico City. While visiting that city, Phoebe A. Hearst saw some of his watercolors and sponsored his studies in Europe. After six years of her support, one of his paintings received first prize at the French Salon. He decided to continue on his own in Paris for eight more years, associating with some of the most important modern artists of the day. Martinez returned to Mexico City in 1910, and two years later accepted the directorship of the Academy of Fine Arts. He served in that position on and off for twelve years and founded the first Outdoor School of Painting in Mexico. His creative, non-academic, approach to instruction had a major impact on the future arts of Mexico through his students who included David Alfaro Siquieros, Jean Charlot and Rufino Tamayo. Martinez married in 1928 and the following year moved to the United States to consult medical specialists about his baby daughter's health. The Martinez family settled in Los Angeles in 1930, and the artist had successful exhibitions in San Diego, Los Angeles, Santa Barbara and San Francisco. During the 1930s he painted murals in Santa Barbara, La Jolla and Coronado. Returning to Mexico in 1942, he remained for two and a half years and painted murals in the Normal School for Teachers in Mexico City. Back in California, he obtained commissions for murals at Scripps College in Claremont and St. Johns Catholic Church in Los Angeles.

53. Fray Junipero Serra (ca. 1938)
pastel and charcoal on brown paper, 32" x 36"
signed upper right
Gift of Caroline Keck (1939.16)

Born on the island of Mallorca in 1713, Father Junipero Serra founded the first Spanish mission in Alta California at San Diego on July 16, 1769. He established eight additional missions in California before his death at Carmel in 1784. One of the most important figures in California's history, numerous artists have undertaken to create their interpreta-

tion of the padre's features as no authenticated portraits of Serra are known.

Martinez here creates a highly stylized depiction of Serra with a group of Indian neophytes. The image of the padre with the robes and tonsure of the Franciscan order is based on figures the artist designed for a procession of monks in the frescos for the Santa Barbara Cemetery Association Chapel executed in 1934. Serra's deeply modeled features are in direct contrast to the broadly drawn faces of the Indians. Cubist influences are evident in the geometrically patterned background and the shallow picture plane is dramatically

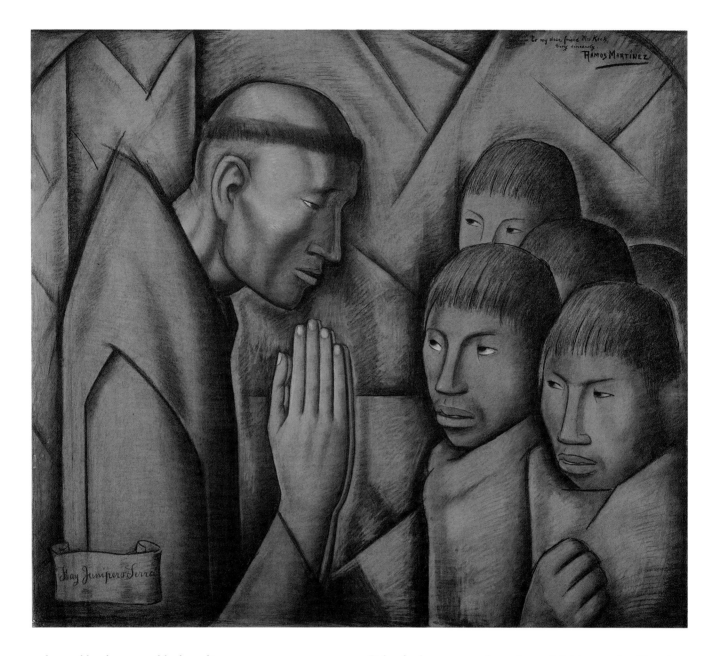

enhanced by the strong black outlines.

Martinez had many ties to San Diego. Soon after his arrival in California, he had a very successful exhibition at the Fine Arts Gallery of San Diego which acquired two pieces for its permanent collection. In 1937, he received the commission to paint a fresco above the main portal of the Mary, Star of the Sea Church in La Jolla. The following year he painted a group of murals for a cafe in Coronado. In the summer of 1940, he taught a six week course at the Fine Arts Gallery. After his final trip to Mexico, Martinez returned to San Diego in January of 1946 at the request of Reginald

Poland who sponsored another exhibition at the Fine Arts Gallery. Martinez and Everett Jackson were good friends and both Jackson and Poland contributed essays to the monograph published by the artist's widow in 1949.

The donor, Caroline Keck (Mrs. Walter M. Keck), was a wealthy citizen of Coronado and patron of the arts. She took art lessons from Martinez.

Works in collection:
1 pastel

Isabelle Schultz Churchman

born: Baltimore, Maryland, April 20, 1896
died: Chula Vista, California, February 25, 1988

Schultz began her art studies at the Maryland Institute of Art in 1914. In 1920, she received a diploma from Columbia Teacher's College in New York. Returning to Baltimore, she enrolled in the Rinehart School of Sculpture where she was awarded a travel scholarship to Europe in 1922. After her studies abroad, she taught in Baltimore for several years. She received the commission to do a portrait relief of Dr. George Washington Carver, the famous African-American scientist, which was dedicated at the Tuskegee Institute in Alabama in 1931. Moving west about 1930, she taught at the Balmer School in La Jolla for three years and afterwards at the Francis Parker School. While working for a W.P.A. project during the Depression she met Edwin Churchman and the couple were married in 1936. They moved briefly to Blythe, where Ed worked as an inspector at the border station, but returned to San Diego in 1941. Multi-talented, Isabelle worked in a variety of media including sculpture, ceramics, watercolors, enamel and mosaic. In her later years she produced many small bronzes using the lost wax method.

54. Dancing Fauns (1922)
bronze, 8 3/4" high
signed on top front of base
Gift of the artist (1980.9.1)

After being graduated from Columbia Teacher's College in February of 1920, Schultz returned to Baltimore where she finished out the year by enrolling at the Rinehart School of Sculpture, a branch of the Maryland Institute. Studying under Ephraim Keyser, she was required to produce an original work each week. At the end of her second year, *Dancing Fauns* received a $600 award in the traveling scholarship competition. With this money, she studied at art centers in Germany, France and Italy. In France she was disappointed to discover that women were not allowed to compete for the Prix de Rome, but later had the satisfaction of knowing that one of her students, Reuben Kramer, won the prestigious award.

Schultz continued to exhibit *Dancing Fauns* after she moved to San Diego in 1930, and had additional casts made for sale. The piece was accepted for the Exhibition of Southern California Art in 1934 and displayed with a show of her work at the La Jolla Art Center in 1944. The Historical Society's bronze has the "ISC" monogram indicating that it was cast after the sculptor's marriage to Ed Churchman in May of 1936. She frequently did additional finish work on her bronzes after they were returned from the foundry and this example shows evidence of hand chasing in several areas.

55. Crest of the Wave (ca. 1934)
bronze, 8 1/2" high
unsigned
Gift of the artist (1980.9.4)

Crest of the Wave exists in several versions, all of which seem to have been produced between 1933 and 1935. One example, possibly a glazed ceramic piece, was exhibited at the San Diego Art Guild's annual exhibition in 1933 where it won Honorable Mention. In 1934, Schultz received the commission to produce a life-size version to be used as a fountain figure for a client in Mentor, Ohio. James Tank Porter cast the full-size bronze at his La Mesa foundry in the summer of 1935. The present location of this piece is not known.

The Historical Society's bronze is unusual in that it is solid cast. Most bronzes of any size are cast hollow to avoid problems of shrinkage and cracking caused by the uneven cooling of the metal. In November of 1935, Schultz exhibited the original model for *Crest of the Wave* at the Los Surenos Art Center in Old Town. This may have been the bronze shown here.

Works in collection:
43 small bronzes, 4 watercolors, 2 ceramic vases,
1 enamel on copper

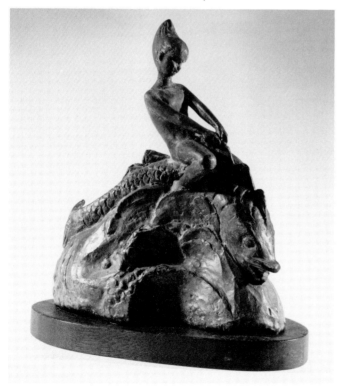

Captain Josiah Grundy

born: Leicester, England, March 22, 1872
died: San Diego, California, March 30, 1946

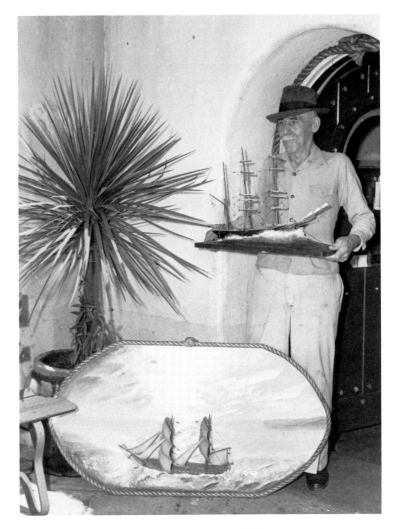

One of San Diego's most interesting naive artists, Grundy indentured himself as a seaman apprentice on the British bark *Yosemite* at the age of fourteen. After eleven years sailing, he went into steamers and achieved prominence in the International Mercantile Marine Company. Becoming marine superintendant at Liverpool for the White Star line, he later served as port warden at Vancouver, B.C.. Retiring from the sea, he settled on a citrus ranch at Lakeside, east of San Diego, in 1922. This proved unsuccessful and he later moved to San Diego. Grundy became a prolific maker of ship models, one of which he presented to Franklin D. Roosevelt. From model making, Grundy progressed to painting ships and some of his canvases were enormous. Ten of his models were exhibited at the California-Pacific International Exposition in 1936. In 1938, he collaborated with Wilkins W. Wheatley on a book called *Square-Riggers Before the Wind*, which outlined his techniques in model building. He maintained a studio at Spanish Village in Balboa Park where he won an Honorable Mention at the Second Annual Art Fiesta in 1938 for a painting of the brig *Pilgrim*. More frequently, he exhibited at hobby fairs and he also appeared on the radio program "Hobby Lobby." A volunteer at Balboa Naval Hospital, he taught model making to some of the patients there.

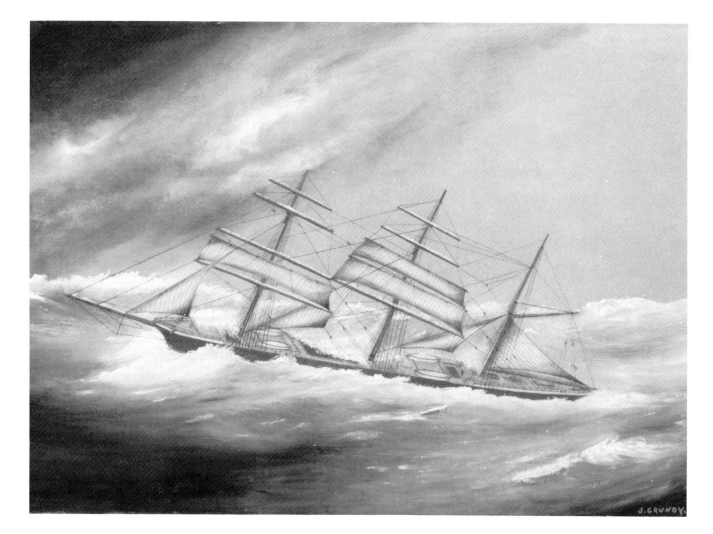

56. Star of India Rounding the Horn (ca. 1935)
oil on board, 18" x 27"
signed lower right
Gift of the artist (1938.2.2)

Commissioned off the Isle of Man in 1864, the *Star of India* began life as the British cargo ship *Euterpe*. She carried immigrants and general cargo to New Zealand via the Cape of Good Hope, returning with a load of wool around Cape Horn. Later owned by the Alaska Packers Assn., her name was officially changed to *Star of India* by act of Congress in 1906. In 1927, local journalist and nautical historian Gerald F. MacMullen helped arrange the purchase of the ship from a scrapyard in San Francisco, and had it towed to San Diego to become a maritime museum. It languished in San Diego Bay until restoration began in 1959.

Grundy never sailed on the *Star of India* but certainly would have been interested in the ship's presence in San Diego Bay. He became an active member of the Maritime Research Society of San Diego. Unlike other local artists who painted the picturesque hulk at dock, Grundy chose to recreate the drama of its years of active service rounding the tip of South America in the face of a storm. Untrained as an artist, Grundy exhibits the naivete and lack of concern with accuracy frequently encountered in folk art. The color scheme is extremely limited and the rigging has been drawn in with a ruler and pencil. In 1955, MacMullen wrote that although lively, many of Grundy's works "...were all out of scale, especially in the matter of rigging, and he had a tendency to name every brig *Pilgrim*, every bark *Star of India* and every four-masted bark *Dirigo*." Although his imagery was limited, there is a certain vivacity and endearing lack of sophistication in Grundy's work that sustains interest.

Works in collection:
2 oils, 1 shadow box model

Wilhelmina (Mina) Schutz Pulsifer

born: Leavenworth, Kansas, August 3, 1899
died: Chula Vista, California, February 14, 1989

A graduate of St. Mary's Academy in Leavenworth, Mina Schutz began art studies at the Kansas City Art Institute. After her marriage to George Pulsifer, the couple moved to San Diego about 1924. In order to continue her art studies, she enrolled at the San Diego Academy of Fine Arts where she studied under Eugene DeVol and Otto H. Schneider. Later she took independent instruction from Nicolai Fechin and Frederick Taubes. An active member of the San Diego Art Guild, she served on its board of directors including a term as president in 1944. She also served on the board of the Spanish Village art center where she maintained a studio. In the 1940s, Pulsifer turned her attention to printmaking, particularly lithography. She received wide recognition in this field and three of her lithographs were distributed by Associated American Artists of New York. During the 1960s she taught life drawing and painting workshops for the San Diego Art Guild. Her later work is boldly painted but maintains the strong sense of line and composition that marks all her work.

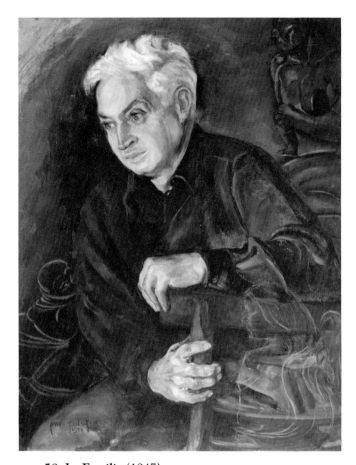

57. Portrait of Donal Hord (1950)
oil on canvas, 30" x 25"
signed and dated lower left
Gift of the artist (1979.16.1)

Pulsifer and San Diego sculptor Donal Hord (see catalogue numbers 30 and 31) were good friends. She owned his plaster nude study for the *Guardian of Water* fountain at the County Administration Building (this study is now in the collection of the Historical Society). In 1943, Hord asked Aloys Bohnen to paint his portrait as part of his obligation to the National Academy of Design upon being accepted as an associate member. Bohnen's portrait was flattering and highly romanticised, but not a particularly good likeness. Pulsifer's portrait is an excellent likeness and admirably captures the sculptor's shyness, intensity and inner strength. At some later date, she added outline images of three of Hord's sculptures, *El Colorado* (1946), *Spring Stirring* (1948) and *Yang Kwei Fei* (1950).

58. La Familia (1947)
lithograph, 9" x 8 1/2" (image)
signed lower right, printed by Paul Roeher
(number 5 of 25 impressions)
Gift of the artist (1979.16.4)

Pulsifer noticed this Mexican couple with child resting between trains at a railroad station waiting room and made a sketch of the scene. She later transferred the image to a litho stone and produced an edition of twenty-five prints. Associated American Artists in New York liked the print and it became the first of her works to be circulated by them. It appeared in their "Patron's Supplement #42" issued in 1947. By producing prints in large editions (usually limited to 250), Associated American Artists was able to offer original works of art at reasonable prices. Many now-famous American artists including Grant Wood and Thomas Hart Benton produced prints for this group. Pulsifer's strong graphic style was well-suited to the lithographic medium and she produced over twenty lithographs.

Works in collection:
5 oils, 5 drawings, 24 lithographs, 2 blockprints

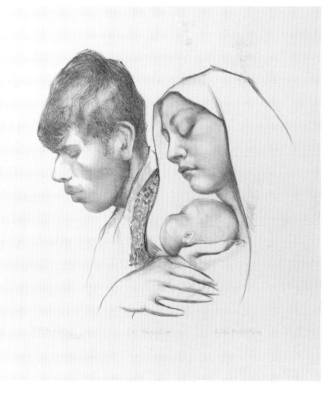

Lowell D. Houser

born: Chicago, Illinois, May 18, 1902
died: Fredericksburg, Virginia, January 3, 1971

Houser's family moved to Ames, Iowa, when he was seven and he received his early education in Iowa. In 1922, he enrolled at the Art Institute of Chicago where he met Everett Jackson who became a close friend. They traveled and painted together in Mexico on several extended trips. In 1927, Houser was invited to join the Carnegie Institute's expedition to the ruins of Chichen-Itza in Yucatan under the direction of Sylvanus G. Morley. For two seasons, Houser assisted Anne Morris and Jean Charlot copying the frescoes from the Temple of the Warriors which were published in 1931. Returning to Ames in 1931, he became involved in several W.P.A. art projects including assisting Grant Wood on murals for the library at Iowa State College, Ames, and creating a mural for the Ames Post Office. Everett Jackson hired him to teach at San Diego State College in 1938. The following year he designed a mural for the Golden Gate International Exposition in San Francisco and had one of his prints accepted for the New York World's Fair. Returning to San Diego in 1944 to teach printmaking, Houser made several more trips to Mexico with Everett Jackson and also James Clark. Ill health forced him to retire in 1957 and he left San Diego, moving to his brother's plantation near Fredericksburg, Virginia. He built a studio there and made a final trip to Mexico in 1962.

59. Haitian Woman (early 1950s?)
oil on masonite, 26" x 23 3/4"
signed lower right
Gift of Everett and Eileen Jackson (1990.92.1)

While working at Chichen-Itza in 1927, Houser met Gustav Stromsvik, an archaeologist for the Carnegie expedition. After the digging season ended, Houser and Stromsvik camped at Biloxi, Mississippi, where they built a twenty-seven foot yawl, using their tent canvas for sails. They named the boat *Wanderlust* and set sail for South America. After visiting Cuba and some of the Caribbean isles, they were shipwrecked during a violent storm. Landing in Haiti, the hospitality of the locals encouraged them to stay for four months. During this period, Houser made numerous drawings and watercolors which later became the basis for oil paintings, block prints and lithographs.

Houser's Caribbean subjects are among the artist's most endearing works and exhibit the innate qualities of humor and good design typical of this artist. *Haitian Woman* is a study in contrasts; the drabness of the metal-roofed hut next to the natural beauty of the bay seen in the distance; the woman's disheveled appearance compared to the flawless perfection of the two conch shells; the cool colors of the tropical landscape versus the dull red of the door drape. The painting was not complete when ill health caused Houser to leave San Diego. He presented it to Everett Jackson upon his departure in 1957.

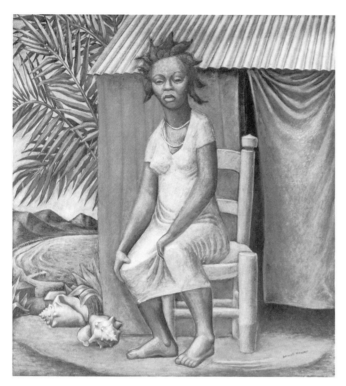

60. Cuban Promenade (late 1940s)
lithograph, 6" x 8 3/4"
signed lower right,
 printed by Lynton Kistler
(number 24 of 25(?) impressions)
Purchased for the Society by an anonymous donor
(1991.8)

In *Cuban Promenade*, Houser creates a delightful vision of two women out for a stroll in the tropical heat. With heads up and fans held high to shield their faces from the sun, they parade by in grand style. The repeated forms and diagonal lines cause the picture to pulsate with movement. Houser has cleverly used a row of fan palms behind the figures to echo the radiating lines of their fans.

Works in collection:
1 oil, 1 lithograph

Dan Dickey

born: New York, New York, March 17, 1910
died: San Diego, California, November 2, 1961

Dickey received his first instruction in art from his father, a commercial artist. During his early education, Dickey attended Saturday classes and summer sessions at the Art Institute of Chicago, where his family lived from 1913 to 1927. Furthering his studies at the American Academy of Art and Worchester Academy in Massachusetts, he received his B.A. degree in English from Carleton College, Minnesota, in 1932. After being graduated, Dickey moved to New York where he continued his studies at the Art Students' League and National Academy of Design where his professors included George Bridgman, Hans Hofmann and Leon Kroll. After touring Europe with his family, Dickey returned to Chicago where he briefly worked as a commercial artist. He became associated with the art colony painting at the Century of Progress Exposition in 1933-34. After the fair, he jumped a boxcar and headed for San Diego's exposition where he arrived in 1935. He worked on the Federal Art Project from 1937 to 1939 and his work in both painting and sculpture started to receive awards beginning in 1938. He exhibited across the country and had one-man shows at the Fine Arts Gallery of San Diego in 1948 and the La Jolla Art Center in 1959. In addition to his artwork, he taught classes at the Fine Arts Gallery and Coronado School of Fine Arts.

61. Two Figures (1940s)
watercolor and gouache, 13" x 9 1/4"
unsigned
Gift of Ettilie Wallace (1983.53.1)

Dickey's figure studies show the influence of Picasso's classicizing nudes of the 1930s with their strong outlines and robust volumes. Not interested in depicting the world as it was, Dickey concerned himself with creating pleasing arrangements of lines, shapes and colors using the idealized human figure as his focus. His paintings were so thoughtfully designed and executed that Everett Jackson referred to him as an "aesthetician." In this work, two generously proportioned women convey a sense of monumentality in spite of the small format. The figures have been arranged solely for the purpose of creating a pleasant combination of curving lines and repeating forms and Dickey has carefully contrasted the deep green gown of the seated figure with the red flower that she holds. Some parts of the work are unfinished.

62. Female Figure (1940s)
black crayon, graphite and ink,
22 1/2" x 17 3/4"
signed upper right
Gift of Ettilie Wallace (1983.53.6)

This study appears to be a somewhat idealized portrait of Melisse Jewell (1896-1963). Melisse, herself an aspiring artist, came to San Diego with her husband, Foster Jewell, in 1932. She met Dickey at the 1935 exposition and although she was fourteen years his senior, the two fell in love. Foster Jewell divorced Melisse in 1937 and left San Diego. Melisse and Dan lived together and she served as the model for many of his figure studies. When his marriage to Ethel Greene ended in 1952 (see catalogue number 63), Dickey became reinvolved with Melisse and eventually married her in 1955. His affection for the model is apparent in this spontaneous and intimate drawing. It is an excellent example of his bold drawing style.

Works in collection:
1 oil, 4 watercolors, 6 drawings,
1 blockprint, archival material

Ethel Greene

born: Malden, Massachusetts, November 11, 1912
(currently residing in Spring Valley, California)

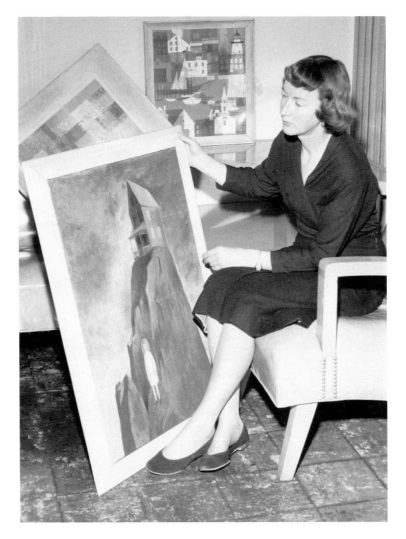

Greene studied at the Boston University School of Art and the School of the Boston Museum before being graduated from the Massachusetts College of Art in 1936. During the Depression she found work with a Boston advertising firm and two greeting card companies. Obtaining a job at Convair in San Diego, she relocated to the west coast in 1943. She later did artwork for the California Division of War Research. From 1945 until 1955 she worked for the Naval Electronics Laboratory on Pt. Loma. It was here that she met Dan Dickey. They were married in 1950, but the marriage lasted only two years. During the war she had done some watercolor paintings, but did not begin to exhibit her work until encouraged by Dickey in the late 1940s. After her retirement in 1955, she purchased a house designed by Lloyd Ruocco that was in the way of freeway development. She moved the structure to Spring Valley and finally had studio space to pursue her artwork in earnest. An active member of the San Diego Art Guild, she served as president in 1956. Since that time she has exhibited extensively and has earned an impressive number of awards. Influenced by Belgian artist Rene Magritte, she is best-known for her own unique form of Surrealism that is often whimsical and full of surprises.

63. Adolescence (1948)
oil on canvas, 31" x 23"
signed lower right
Gift of the artist, (1990.60)

Originally titled *House on the Peak*, this painting marks a turning point in Greene's career as an artist. Previously, she had been painting mild watercolors and experimenting with abstract and non-objective subjects. In this work she intentionally set out to create an unusual and dramatic picture in the hope of surprising Dan Dickey whom she greatly admired. Greene chose as her subject an ordinary Victorian house, similar to the one in which she was born and raised, but placed it in an extraordinary location. The house begins to take on anthropomorphic characteristics with its eye-like windows and toothy porch rails. It even bends slightly and seems surprised at its own precarious position.

As the composition developed, Greene decided to add a figure which changed the mood from dramatic to somber. This is not a happy young girl with friends and interesting pastimes, but a solitary frail figure in glasses who stares out from a threatening landscape, unable to ascend or descend. Is she struggling to be free of the secure but often restraining nature of home and take that first brave step into the unknown world outside, or is she attempting to return to the refuge of home but not able to find her way? For Greene, the figure symbolized the helplessness of adolescence.

Dan Dickey was surprised and pleased with the picture and encouraged Greene to show it. Her first publicly exhibited painting, it received an award at the San Diego County Fair in 1948. Two years later it was accepted for the Annual Exhibition of Artists of Los Angeles and Vicinity at the Los Angeles County Museum of Art. This success convinced Greene to continue in the realm of "story pictures," and imaginary subjects remain the primary focus of her work to this day.

Works in collection:
1 oil

Jean Swiggett

born: Franklin, Indiana, January 6, 1910
died: San Diego, California, December 8, 1990

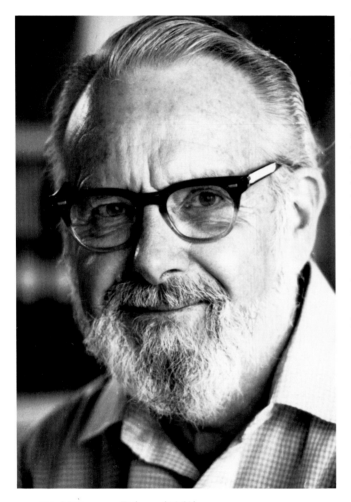

Swiggett's family moved to Long Beach when he was two years old and he received his early education in that city. Graduated from Long Beach Junior College in 1930, he entered the Chouinard Art Institute in Los Angeles the following year. He transferred to San Diego State College where he studied under Everett Jackson and was graduated in 1934. Returning to Long Beach, Swiggett became involved with the W.P.A., painting murals for post offices in Huntington Park, Redondo Beach, and his birthplace, Franklin, Indiana. While working for the W.P.A. he continued his education receiving his M.F.A. degree from the University of Southern California in 1939. He began exhibiting in 1935 and had a painting included in the Golden Gate International Exposition in San Francisco in 1939. Swiggett taught briefly during the war years before attending the Officer Candidate School in Florida after which he became head of the Department of Radar Intelligence at Victorville Army Air Base. In 1946, Everett Jackson hired him as a professor at San Diego State College where he remained for 31 years. He served three separate terms on the board of the San Diego Art Guild including a term as president in 1953. From 1963 to 1969 he chaired the art department at San Diego State College. Swiggett traveled and painted all over the world. His work was included in over 600 exhibitions internationally and he received over 150 awards. In 1987, a major retrospective was held at San Diego State University.

64. Niños con Paletas (1950)
oil on canvas, 30" x 25"
signed lower right
Gift of the artist's daughter, Stephanie Gould (1991.1)

As in all of Swiggett's work, a sense of mystery pervades. One would expect three young boys with ice cream to be happy, but these trouserless youths stare out blankly from a world in disarray. Standing in a yard of trash and broken things, the boys are separated from the well-kept buildings and church dome by a low wall and section of metal grating. They also seem to be separated emotionally from the wealth and dogma those structures represent. The composition is based on a network of complicated linear patterns with the faces of the children forming a strong diagonal through the center. The color scheme has been limited to an icy blue-green, dull red and pale yellow. These colors are carefully balanced and echo in the children's treats, but even the momentary pleasure of something cold and sweet cannot overcome the poverty of their existence.

Works in collection:
1 oil

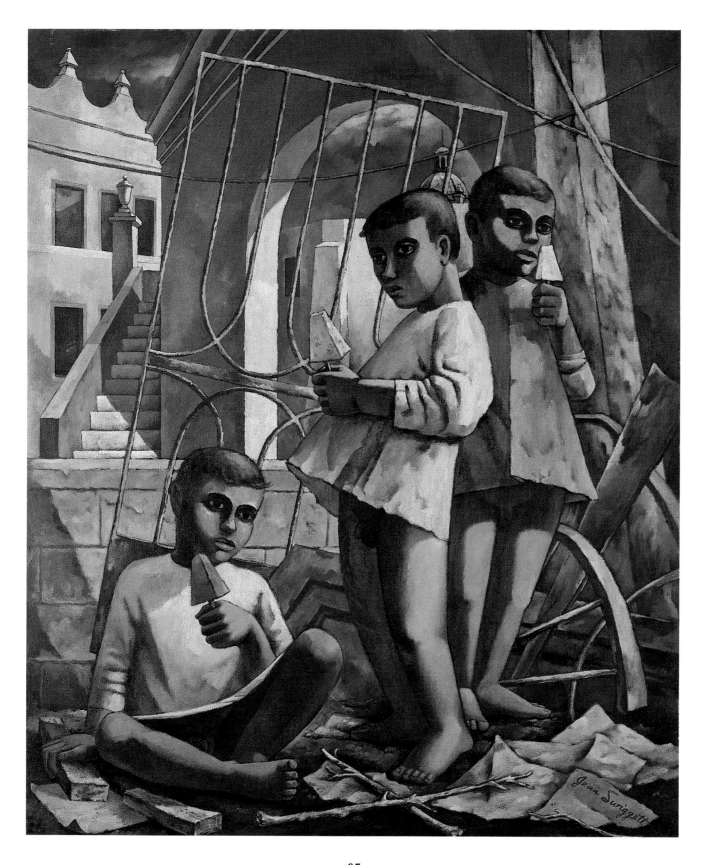

97
SWIGGETT

James R. Clark

born: Boston, Massachusetts, September 14, 1918
(currently residing in San Diego)

Clark moved to San Diego with his family in 1924 and his parents built a home on Point Loma the following year. As a youth, he studied clay modeling with Anna Valentien and oil painting with John L. Stoner in the early 1930s. In 1936, he enrolled at San Diego State College where his instructors included Everett Gee Jackson, Lowell Houser and Ilse Ruocco. After graduation in 1940, he taught junior high school art from 1940 to 1942. During the early years of the war, John Stoner hired him to make perspective drawings of airplane parts at Rohr Aircraft. He was later drafted into the Navy and sent to Newport, Rhode Island, where he did artwork for the Training Aids Department. On the G.I. Bill he continued his studies at Columbia University in New York where he obtained a masters degree in art. Returning to San Diego, he began teaching at Kearny High School where he remained for thirteen years. He later served as an art teacher consultant for thirty-seven secondary schools in the San Diego district. In 1965, he began teaching at Mesa Junior College and although he officially retired in 1979, he continues to teach a class in life drawing.

65. Television (1951)
lithograph, 11" x 8 3/4"
signed and dated lower right margin
(number 8 of 10 impressions)

Gift of the artist (1987.57)
The first public television broadcast took place on April 30, 1939, when President Franklin D. Roosevelt was televised at the opening ceremonies of the New York World's Fair. It is doubtful that any other invention has had as dramatic an impact on the second half of the 20th century. Television was just becoming popular during the time that Clark was studying at Columbia University in 1946-47. While there, Clark took a class in lithography from Arthur Young in the Fall of 1946 and became Young's assistant the following semester. After returning to San Diego, Clark assisted Lowell Houser with the lithographic program at San Diego State College. They began using zinc plates instead of litho stones because the finely grained limestone blocks had become difficult to obtain.

The idea for this print came while Clark observed his brother's children who were on a visit. He drew the composition on stone from memory and then printed it himself in a small edition. His highly stylized image admirably captures the children's sense of fascination and zombie-like stares. The print was accepted for exhibition at the Los Angeles and Vicinity annual show at the Los Angeles County Museum of Art in 1952. Sometime later he did a painting of the same subject which he called *Color Television*.

Works in collection:

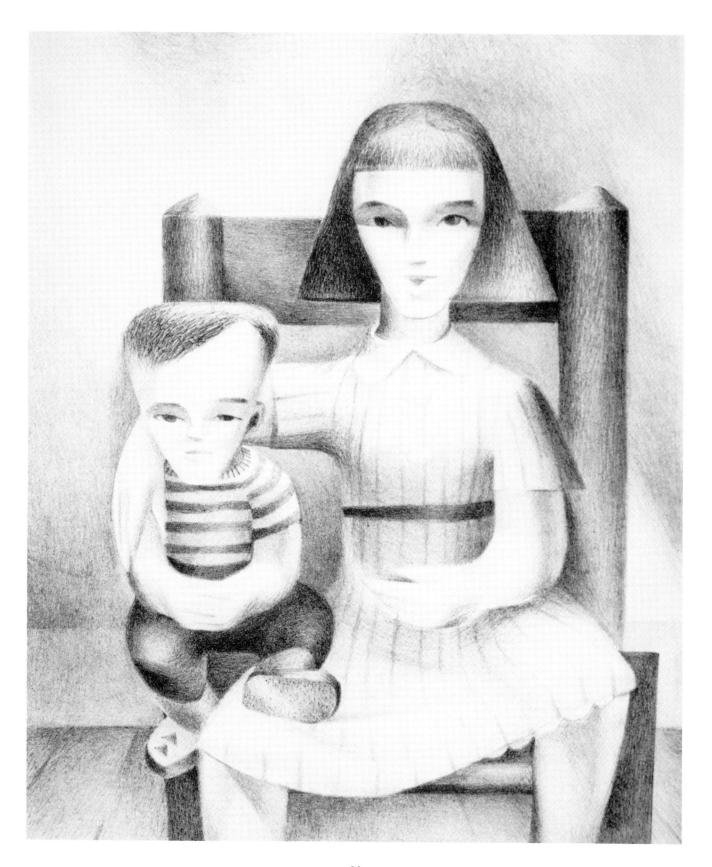

William Munson

born: Denver, Colorado, August 11, 1922
died: San Diego, California, December 27, 1957

Munson arrived in San Diego in 1939 and soon entered military service in the Army. After World War II, he was discharged and took advantage of veteran educational opportunities to study art. He attended the Coronado School of Fine Arts under Monty Lewis from 1947 to 1952 and taught watercolor at the school in 1954. Munson developed rapidly as an artist and soon began to receive important awards. He won prizes at the California State Fair in 1951, Los Angeles County Artists Group in 1953 and 1957, California Watercolor Society in 1954, and prizes in both the conserva-tive and modern sections of the Southern California Exposition in 1955. In 1956, he had a one-man show at the La Jolla Art Center. By the late 1950s, Munson was considered to be one of the fastest rising young talents in San Diego. Tragically, he was killed in an automobile accident on the Mission Bay Bridge when he was thirty-five years old. Monty Lewis organized a memorial exhibition of thirty-two pieces at the Fine Arts Gallery of San Diego in March of 1958. A memorial scholarship in Munson's name was later established at the Coronado School of Fine Arts.

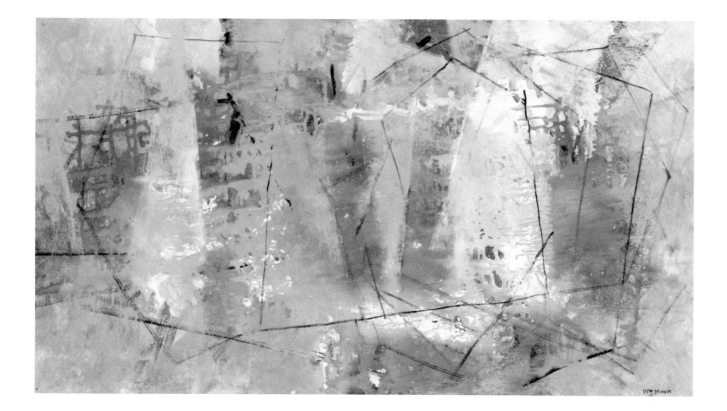

66. Sea Shore (1957)
oil on masonite, 22" x 40"
signed lower right, dated on reverse
Gift of Ursula and Barbara Britton (1989.35)

Munson was one of the most progressive of the younger artists working in San Diego in the 1950s. His early works were based primarily on abstract but still recognizable images of architecture and human figures. In *Sea Shore*, completed shortly before the artist's death, Munson advanced to a completely non-objective interpretation. A chaotic jumble of blues, whites and tans reflects the elements of the shore, its water, foam and sand, but places them outside their expected relationships.

James Britton, a prominent and outspoken local art critic, became a strong supporter of Munson. In an October 1954 issue of *Point*, Britton wrote "The lines and shapes in a Munson painting usually work together to produce a feast for the eyes that studies them." He went on to call Munson "...one of the truly gifted painters of San Diego." *Sea Shore* belonged to Britton and was donated to the Historical Society by his daughters.

Works in collection:
1 oil

Ferdinand (Fred) Hocks

born: Aix-la-Chapelle, Aachen, Germany, October 8, 1886
died: San Diego, California, October 16, 1981

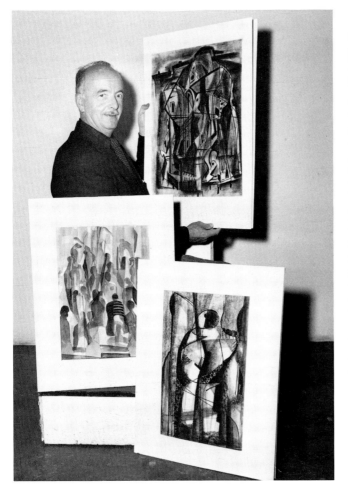

Descending from Dutch nobility, Hocks experienced art at an early age. His father owned rare master prints and paintings including ancestor portraits by Anthony Van Dyck. In 1902, Hocks immigrated to the United States settling in San Francisco. He enrolled at the Mark Hopkins Institute of Art where he studied under Arthur Mathews. After the 1906 earthquake, he traveled to New York where he continued his studies at the Art Students' League. He left New York before the 1913 Armory Show to return to San Francisco, but saw parts of that famous exhibition at the Panama-Pacific International Exposition in 1915. Continuing his studies at the California School of Fine Art, he exhibited with a group of young painters called the Independent Artists. In 1924, Hocks obtained a position as instructor of a summer session for students of the Los Angeles Academy of Art at Jamacha near San Diego. He built a studio on a forty acre site in Sweetwater Valley in 1930. Hocks joined the W.P.A. Art Project in 1936, but was not happy and returned to San Francisco to work on exhibits for the Golden Gate International Exposition. After World War II, he became a co-director of the San Diego School of Arts & Crafts in La Jolla. His backcountry studio burned in 1947 destroying hundreds of his early paintings. In the 1950s, Hocks made several trips to Europe and Mexico and had exhibitions in Paris, Mallorca and Guadalajara. From the late 1950s until 1976, he taught at the Coronado School of Fine Arts.

67. Untitled (1958)
mixed technique, 23" x 17 1/4" (sight)
signed and dated lower right, monogram lower left
Gift of Harry and Virginia Evans (1983.39)

One of the most adventurous of local artists, Hocks was an intelligent and articulate defender of modern tendencies in art. He wrote "A painting to be worthy of the name art, must necessarily have elements of indefinable qualities, which for the want of a better name we term abstract, irregardless whether the abstract quality is diffused by subject matter or rests on its own merit."

In this work, Hocks has created an overlapping layered effect of primarily transparent colors. The bottom layer appears to have been painted and then scraped back to reveal the bare white of the paper while the upper layers seem to be stenciled and painted. He has taken the primary colors of red, yellow and blue, but transformed them into a blood red, yellow ochre and dark, almost black, blue. The soft painted shapes contrast with hard-edge stenciled shapes.

Works in collection:
1 mixed technique

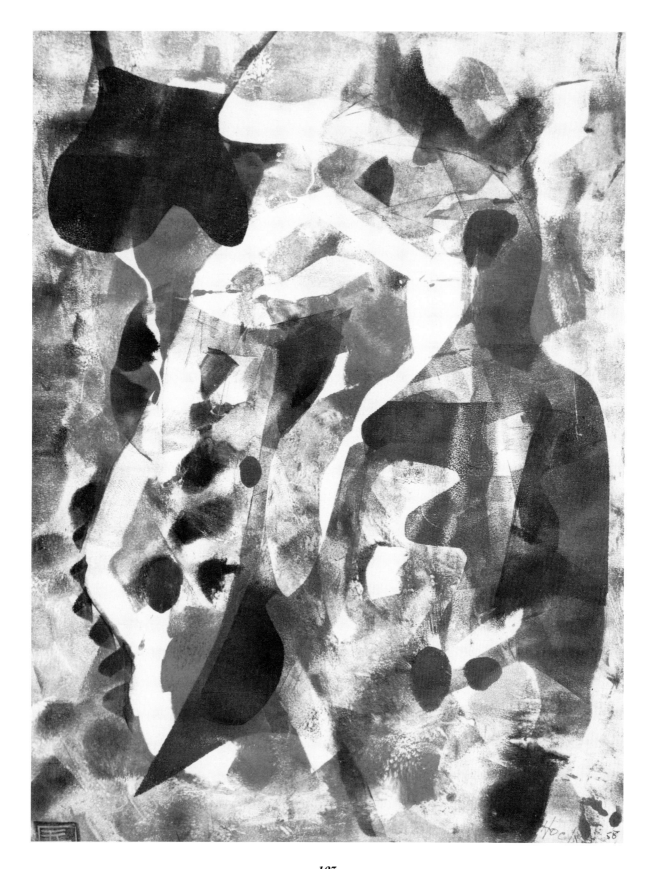

103
HOCKS

John Dirks

born: Fond du Lac, Wisconsin, March 13, 1914
(currently residing in La Mesa, California)

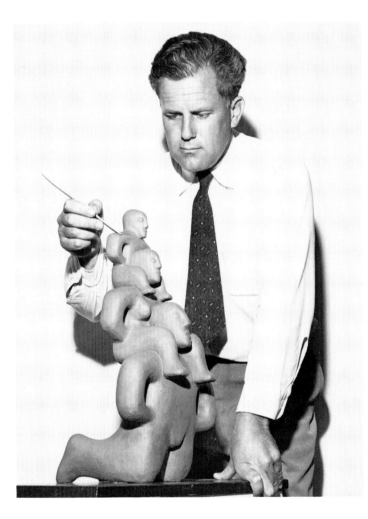

Dirks arrived in San Diego with his family in 1921. An avid model builder as a youth, he developed skills which later became useful in his sculpture and crafts work. Studying art and design at San Diego State College, he was greatly influenced by Everett Gee Jackson, Lowell Houser and Ilse Ruocco. After graduation in 1937, Dirks taught high school crafts in San Diego and studied with ceramist Glen Lukens at the University of Southern California. He later obtained a M.F.A. degree from Claremont Graduate School in 1960. Enlisting in the Navy during World War II, Dirks was stationed in Rhode Island and the San Francisco Bay Area where he later ran the thirty-two area hobby shops, the father of all U.S. military hobby programs. Returning to San Diego, he continued to produce small sculptures in ceramic and exotic hardwoods which were sold through Gump's in San Francisco from 1949-53. He also made custom furniture and started a furniture design class at San Diego State College, the first such class in the state. Dirks served as president of the San Diego Art Guild in 1949 and won three first place awards for sculpture from the group including Best of Show in 1961. He has also won awards in several national invitational competitions and his work has been published in *Architectural Forum, House Beautiful, House and Garden* and other publications. His most important commission has been an eleven foot teakwood sculpture *The Tree of Justice* for the Vista Regional Center, dedicated in 1978.

68. Column II (1965)
laminated Honduras mahogany,
73" high (with base)
signed bottom front
Purchased for the Society through the
Mrs. William A. Edwards Curatorial Fund
and two anonymous donors
(1990.84)

Column II is an enlargement of a smaller piece in teak-wood thirty-nine inches high which the sculptor created in 1960. This first version was exhibited at Palomar College and also at the California-Hawaii Invitational exhibition at the Fine Arts Gallery.of San Diego In these two pieces, Dirks explored the concepts of sending and receiving, Yin and Yang, and offered the alternative title "Union of Positive and Receptive Forms." In the Chinese Taoist belief system, Yin and Yang are the principles of female and male energy, embodied in both the material and spiritual world, which need to be kept in proper balance for harmony to exist. Each of the five modules that make up the sculpture have a positive and receptive aspect.

Dirks once said "I feel that modular monotony is bad and that I don't particularly like it in modern building." He avoided this problem by alternating the direction of the picture tube-like shapes and having them increase in size as they approach the top. He has also made the bottom module vertical which enhances the soaring aspect of the piece. Additionally, Dirks carefully assembled the individual boards forming the lamination according to their inherent variations in color, thereby creating a subtle vertical band down the center of the form which helps to emphasize the sculpture's monumentality. The total effect is one of classical strength and simplicity underscored by the excellent craftsmanship that marks all of Dirks' work.

Column II was exhibited at Dirks' one-man show in the Founder's Gallery of the University of San Diego in 1973. In 1978-79 it was shown at the Mex-Art International gallery in La Jolla operated by Professor Julio Tejada of Mexico City.

Works in collection:
1 wood

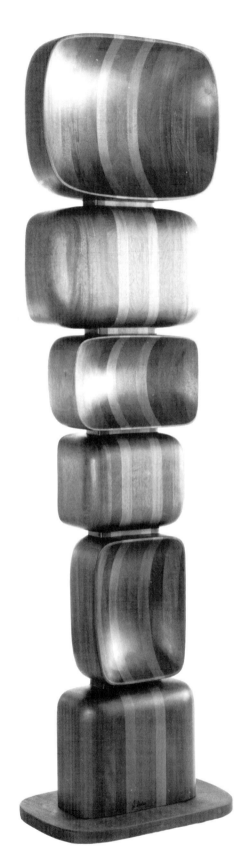

Selected Bibliography of San Diego Art

BOOKS:

Andrews, Julia Gethman, *A Catalogue of European Paintings 1300-1870*, Fine Arts Gallery of San Diego, 1947

Blavatsky, Helena P., *Collected Writings 1889-1890*, Wheaton, Ill., 1980 (re. "Reginald Willoughby Machell" Vol. XII, Appendix)

Dixon, Ben F., ed., *Too Late," The Picture and the Artist*, San Diego, 1969 (biography and catalogue of Charles Fries)

Federal Art Project of Southern California, *San Diego Civic Centre Fountain and Donal Hord, Sculptor*, no publ. or date (intro. by Stanton Macdonald-Wright)

Fine Arts Society of San Diego, *The Fine Arts Gallery of San Diego Catalogue*, 1960

Geiger, Maynard, *Father Junipero Serra Paintings*, Santa Barbara, 1958

Greenwalt, Emmett A., *California Utopia: Point Loma: 1897-1942*, San Diego, 1978 (re. Theosophical Society)

Heyneman, Julie Helen, *Desert Cactus, The Portrait of a Sculptor*, London, 1934 (biography of Arthur Putnam)

Hughes, Edan Milton, *Artists in California 1786-1940*, San Francisco, 1989 (biographical dictionary)

Jackson, Everett Gee, *Burros and Paintbrushes, A Mexican Adventure*, Texas A & M Univ., 1985 (autobiographical)

_____, *It's a Long Road to Comondu, Mexican Adventures since 1928*, Texas A & M Univ., 1987 (autobiographical)

Mallory, John A., *Spanish Village*, San Diego, 1939

Martinez, Maria Sodi de Ramos (trans. by Berta de Lecuona), *Alfredo Ramos Martinez*, Los Angeles, 1949 (contributions by Donald Bear, Federico Cantu, Everett Jackson & Reginald Poland)

Messenger, Ivan, *Not for Tourists Only: An Early Portrait of San Diego*, San Diego, 1969

Miller, Dorothy, C., ed., *Americans 1942*, Museum of Modern Art, New York, 1942 (section on Donal Hord)

Moure, Nancy Dustin Wall, *Southern California Art*, Los Angeles, 1984, Vol. I: *California Water Color Society, Index to Exhibitions 1921-54*, Vol. II: *Artists' Clubs and Exhibitions in Los Angeles Before 1930*, Vol. III: *Dictionary of Art and Artists in Southern California Before 1930*

Neuerburg, Norman *The Decoration of the California Missions*, Santa Barbara, 1987

Neuhaus, Eugen, *The San Diego Garden Fair*, San Francisco, 1916

Nolan, James L., *Discovery of the Lost Art Treasures of California's First Mission*, San Diego, 1978

Nostrand, Jeanne van, *The First Hundred Years of Painting in California 1775-1875*, San Francisco, 1980

Perine, Robert, and I. Andrea, *San Diego Artists*, Encinitas, 1988 (with historical essay by Bram Dijkstra)

Peters, Harry T., *California on Stone*, Garden City, 1935 (Arno Press reprint, 1976)

Westphal, Ruth Lilly, *Plein Air Painters of California: The Southland*, Irvine, 1982 (with San Diego section by Martin Petersen)

UNPUBLISHED PAPERS, JOURNALS AND THESES:

Boettger, Suzaan, *The Art History of San Diego to ca. 1935*, City Univ. of New York, 1985

Kamerling, Bruce, ed., *Index to Competitive Art Exhibitions Held in San Diego Before World War II*, San Diego Historical Society, 1988

_____, *A Curatorial Examination of Certain Works of Art in the Possession of the City of San Diego*, San Diego Historical Society, 1990

Lee, Leslie, *Journal (1909-1949)*, handwritten (California Room, San Diego Public Library)

Lytle, Rebecca Elizabeth, *People and Places: Images of Nineteenth Century San Diego*, San Diego State Univ., 1978

Mehren, Peter William, *The WPA Federal Arts Projects and Curriculum Project in San Diego*, Univ. of California Davis, 1972

San Diego County Library Extension Service Project 5682, *What They Do* "A Pictorial Review of Representative Projects of the Professional and Women's Division of the Works Progress Administration, District No. 12, State of California with Explanatory Text," 1937 (copy at San Diego Historical Society Research Archives)

EXHIBITION CATALOGUES:

Anderson, Thomas, R., and Bruce Kamerling, *Sunlight and Shadow: The Art of Alfred R. Mitchell, 1888-1972*, San Diego Historical Society, 1988

Anderson, Timothy J., Eudorah M. Moore, Robert W. Winter, *California Design 1910*, Pasadena, 1974

California First Bank, *A Donal Hord Retrospective*, La Jolla, 1976 (with reminiscences by Homer Dana)

de Saisset Art Gallery and Museum, *New Deal Art: California*, University of Santa Clara, 1976

Gallery Stares, *Mina Pulsifer, A Retrospective*, San Diego, 1990 (intro. by Bruce Kamerling, preface by Ken Self, Jr., and Pamela Bensoussan)

Long Beach Museum of Art, *Arts of Southern California XIV, Early Moderns*, 1963 (includes Dan Dickey and Fred Hocks)

Mandeville Gallery, *Belle Baranceanu - A Retrospective*, Univ. of California, San Diego, 1985 (essays by Bram Dijkstra and Anne Weaver)

Petersen, Martin, *Second Nature: Four Early San Diego Landscape Painters 1895-1945*, San Diego Museum of Art, 1991 (includes C. A. Fries, M. Braun, A. R. Mitchell, and C. Reiffel)

San Diego Fine Arts Gallery, *Exhibition of Historic Art*, California Centennial Celebration, 1950 (essays by Reginald Poland and Ivan Messenger)

San Diego Museum of Art, *A Selection of Paintings by Early San Diego California Artists*, 1987

Trenton, Patricia, and William H. Gerdts, *California Light 1900-1930*, Laguna Art Museum, 1990 (includes Maurice Braun)

PERIODICALS:

The Art Digest "Special Number on the California-Pacific Exposition," Vol. IX, No. 18 (July 1, 1935)

Ball, Ruth N., "Collaborating in Art" *The Modern Clubwoman*, Vol. III, No. 3 (Dec. 1929)

Braun, Maurice, "Theosophy and the Artist" *The Theosophical Path*, Vol. XIV, No. 1 (Jan. 1918)

Britton, James, "Another Election Sensation" *Point*, Vol. II, No. 16 (May 4, 1951), (re. San Diego Art Guild and separation of modern and conservative works)

_____, "Progressive is Progressive" *Point*, Vol. II, No. 19 (May 25, 1951), (re. Allied Artist Council)

_____, "Culture has Bugs" *Point*, Vol. III, No. 1, (July 20, 1951), (re. moderns vs. conservatives at County Fair)

_____, "Les Earnest's Brood" *Point*, Vol. III, No. 5 (Aug. 17, 1951), (re. Spanish Village)

_____, "Art Council Hits Hardpan" *Point*, Vol. III, No. 9 (Sept. 14, 1951), (re. San Diego Art Council)

_____, "The Spirit of Dan Dickey" *Point*, Vol. III, No 14 (Oct. 19, 1951)

_____, "A Well-Balanced Life" *Point*, Vol. VI, No. 2 (Jan. 2, 1953), (re. Monty Lewis and Coronado School of Fine Arts)

Brown, Suzanne Blair, "The Prime of Belle Baranceanu" *San Diego Magazine*, Vol. 37, No. 9 (July, 1985)

DeVol, Pauline Hamill, "Youth in Art" *The Modern Clubwoman*, Vol. III, No. 5 (Feb., 1930)

Ellsberg, Helen, "Donal Hord: Interpreter of the Southwest" *American Art Review*, Vol. IV, No. 3 (Dec., 1977)

Houk, Walter, "Hommage to Everett Jackson" *San Diego Magazine*, Vol. 31, No. 7 (May 1979)

Jackson, Everett Gee, "Modernism Without Apologies" *The Modern Clubwoman*, Vol. IV, No. 1 (Sept., 1930)

James, George Wharton, "Harry Cassie Best, Painter of the Yosemite Valley, California Oaks and California Mountains" *Out West* (Jan., 1914)

Kamerling, Bruce "Anna and Albert Valentien: The Arts and Crafts Movement in San Diego" *Journal of San Diego History*, Vol. XXIV, No. 3 (Sum., 1978)

_____, "Theosophy and Symbolist Art: The Point Loma Art School" *Journal of San Diego History*, Vol. XXVI, No. 4 (Fall, 1980), (with biographical sketches of 8 artists)

_____, "The Start of Professionalism: Three Early San Diego Artists" *Journal of San Diego History*, Vol. XXX, No. 4 (Fall, 1984), (includes E. Chapin, Wm. T. Black, and A. M. Farnham)

_____, "Like the Ancients, the Art of Donal Hord" *Journal of San Diego History*, Vol. XXXI, No. 3 (Sum., 1985), (includes complete catalogue of work)

_____, "Painting Ladies: Some Early San Diego Women Artists" *Journal of San Diego History*, Vol. XXXII, No. 3 (Sum., 1986), (with biographical sketches of 33 artists)

_____, "Anna & Albert Valentien: The Arts and Crafts Movement in San Diego" *Arts & Crafts Quarterly*, Vol. I, No. 4 (July, 1987), (revision of 1978 article)

_____, "California's Leonardo: The Portraits of Signor Barbieri" *California History*, Vol. LXVI, No. 4 (Dec., 1987)

_____, "Leslie and Melicent Lee: Artist, Author and Friends of the Indian" *Journal of San Diego History*, Vol. XXXIV, No. 2 (Spr., 1988)

_____, "Early Sculpture and Sculptors in San Diego" *Journal of San Diego History*, Vol. XXXV, No. 3 (Sum., 1989), (with biographical sketches of 16 artists)

_____, "Arthur Putnam, Sculptor of the Untamed" *Antiques & Fine Art*, Vol. VII, No. 5 (July/Aug., 1990)

Lester, Leonard "A New Trend in Art Criticism" *The Theosophical Path*, Vol. XIII, No. 3 (Sept., 1917)

_____, "Thoughts on Current Art" *The Theosophical Path*, Vol. XIV, No. 1 (Jan., 1918)

Lovoos, Janice "The Sculpture of Donal Hord" *American Artist*, Vol. 23, No. 7 (Sept., 1959)

Lytle, Rebecca, "People and Places, Images of 19th Century San Diego in Lithographs and Paintings" *Journal of San Diego History*, Vol. XXIV, No. 2 (Spr., 1978)

Machell, Reginald, "Symbolism in Nature and in Art" *The Theosophical Path*, Vol. XIII, No. 5 (Nov., 1917)

_____, "Art from a Theosophical Standpoint" *The Theosophical Path*, Vol. XXII, No. 5 (May, 1922)

MacPhail, Elizabeth, "Allen Hutchinson: British Sculptor" *Journal of San Diego History*, Vol. XIX, No. 2 (Spr., 1973)

Meixner, Mary L., "Lowell Houser and the Genesis of a Mural" and "The Ames Corn Mural" *The Palimpsest*, Vol. 66, No. 1 (Jan./Feb., 1985)

Mitchell, Alfred R., "Thoughts on Art" *The Modern Clubwoman*, Vol. III, No. 3 (Dec., 1929)

Morris, Kenneth, "R. W. Machell" *The Theosophical Path*, Vol. XXXIII, No. 3 (Sept., 1927)

Neuerburg, Norman, "The Angel on the Cloud, or 'Anglo-American Myopia' Revisited: A Discussion of the Writings of James L. Nolan" *Southern California Quarterly*, Vol. LXII, No. 1 (Spr., 1980)

_____, "The Changing Face of Mission San Diego" *Journal of San Diego History*, Vol. XXXII, No. 1 (Win.,1986)

Osborne, Carol M., "Arthur Putnam, Animal Sculptor" *American Art Review*, Vol. III, No. 5 (Sept./Oct., 1976)

Petersen, Martin E., "Contemporary Artists of San Diego" *Journal of San Diego History*, Vol. XVI, No. 4 (Fall, 1970), (includes biographical sketches of 11 artists)

_____, "Alfred R. Mitchell: Pioneer Artist in San Diego" *Journal of San Diego History*, Vol. XIX, No. 4 (Fall, 1973)

_____, "Maurice Braun: Master Painter of the California Landscape" *Journal of San Diego History*, Vol. XXIII, No. 3 (Sum., 1977)

_____, "Success at Mid-Life: Charles Reiffel, 1862-1942, San Diego Artist" *Journal of San Diego History*, Vol. XXXI, No. 1 (Win., 1985)

_____, "Maurice Braun, Painter of the California Landscape" *Art of California*, Vol. 2, No. 4 (Aug./Sept., 1989)

_____, "San Diego Museum of Art" *Art of California*, Vol. 3, No. 5 (Sept., 1990)

Poland, Reginald, "The Divinity of Nature in the Art of Maurice Braun" *The Theosophical Path*, Vol. XXXIV, No. 5 (May, 1928)

_____, "Charles Arthur Fries" *The Modern Clubwoman*, Vol. III, No. 2 (Nov., 1929)

Reiffel, Charles, "The Modernistic Movement in Art" *The Modern Clubwoman*, Vol. III, No. 4 (Jan., 1930)

Stewart, Maud Merrill, "Women Artists of Ocean Beach" *The Modern Clubwoman*, Vol. IV, No. 2 (Nov., 1931)

Stimmel, William, "Focal Point" *Omniart*, Vol. I, No. 10 (Oct., 1962), (re. Donal Hord sculpture)

Sullivan, Catherine, "Donal Hord" *American Artist*, Vol. 14, No. 8 (Oct., 1950)

San Diego Magazine "Fine Arts Number," Vol. 3, No. 10 (Sept., 1927), (numerous articles on local artists and art-related topics)

Spanish Village Quarterly, Vol. I, No. 1 (Spr., 1941), (contributions by Dan Dickey, Lorser Feitelson, Everett Jackson, Stanton MacDonald-Wright and Reginald Poland)

Spanish Village Quarterly, Vol. I, No. 2 (Fall, 1941), (contributions by Julia Andrews, Belle Baranceanu, Dan Dickey, Donal Hord and Sherman Trease)

The Western Architect "A Unique Tile House," Vol. XIII, No. 4 (Apr., 1909), (re. home of Felix Peano)

The Western Woman "San Diego Souvenir Edition," Vol. 10, No. 9 (Sum., 1942), (numerous articles on local art and artists)

Additional Artists Represented in the Collection of the San Diego Historical Society

Clark Allen (b. 1925)
Anita Brown Amos (b.1912)
Robert H. Asher (1868-1953)
Celeste Batiste (1877-1963)
Violet Beck (1886-1989)
Grace (Gay) Betts (1883-1978)
Fred A. Binney (late 19th cent.)
Aloys Bohnen (1887?-1967)
Dorothy E. Buckley (20th cent.)
Eliza A. Burns (late 19th cent.)
Edwin T. Churchman (1904-1969)
Constance Emily Comer (early 20th cent.)
John B. Comparet (1848-1929)
Edward H. Davis (d.1951)
Henri de Kruif (1882-1944)
Amy Donaldson (1893-1987)
Elise Donaldson (1887-1980)
Helen Dowd (b.1906)
J. Milford Ellison (b.1909)
William A. Eskey (1891-1937)
Walter J. Fenn (1862-1961)
Margaret Eddy Fleming (1888-1977)
Henry Chapman Ford (1828-1894)
Isaac J. Frazee (1858-1942)
Jane G. Gale (1899-1987)
Frances M. Geddes (1888-1947)
Bess Gilbert (1897-1965)
Nellie Stearns Goodloe (1862-1945)
Benjamin Gordon (d.1940)
Florence Chenett Hale (1887-1945)
Rose Hanks (1890-1979)
Florence Hord (b.1903)
Lydia Knapp Horton (1843-1926)
Bertha Huntley (1875-1958)
Foster Jewell (b.1893)
Melisse Jewell (1896-1963)
Martha Miles Jones (1870-1945)
Richmond I. Kelsey (b.1905)
Fred Kettler (early 20th cent.)
Elsie Kimberly (d.1966)
Leda Klauber (1881-1981)
Grace Knoche (1871-1962)
Juanita (Nita) Krog (b.1901)
Anna Coleman Ladd (1878-1939)

Emily Elnora (Nora) Landers (1853-1950)
Alice Hulick Preston Lavallee (1896-1984)
James H. Lavallee (1904-1980)
Marian Lester (b.1893)
Beatrice Levy (1892-1974)
Henry Lion (1900-1966)
Thaddeus J. Lords (1887-1983)
Katherine H. MacDonald (1882-1967)
Alfred E. Mathews (1831-1874)
Charles P. Neilson (early 20th cent.)
Edward C. Northridge (1902-1949)
Robert Miles Parker (b.1939)
Grace Storey Putnam (1877-1947)
Leyon G. Randall (1890?-1969)
Marjorie Reed (b.1915)
Barney M. Reid (b.1913)
Winifred Rieber (1872-1963)
Jeanne Rimmer (b.1914)
Jean Rittenhouse (1871-1953)
Charles J. Ryan (1865-1949)
Fannie L. Ryan (late 19th/early 20th cent.)
Cartaino Scarpitta (1887-1948)
Rose Schneider (1895-1976)
Frederick Schweigardt (1885-1948)
Julia G. Severance (1877-1972)
Walter Shawlee (1911-1978)
Hazel Brayton Shoven (1884-1969)
Charles A. Small (d.1962)
Eva Smith (late 19th cent.)
W. Thompson (Tom) Stephens (1913-1985)
Betty Shropshire Stoner (b.1906)
John L. Stoner (1906-1976)
Dorothy Stratton (b.1908)
Mabel E. Sumerlin (1879-1956)
Eugene L. Taylor (1898-1955)
Aime Baxter Titus (1883-1941)
Sherman Trease (1889-1941)
John Terrell Vawter (1879-1919?)
Della Vernon (1876-1962)
Franco Vianello (b.1937)
Mary Gordon Volkmann (1898-1985)
Norah Woodward (1893-1988)
Edith Wynn (early 20th cent.)
Marco Zim (1880-1963)